the Joy of LETTERING

Walter Foster

Quarto is the authority on a wide range of topics.
Quarto educates, entertains, and enriches the lives of our readers—
enthusiasts and lovers of hands-on living.
www.quartoknows.com

Acquiring & Project Editor: Stephanie Carbajal
Page Layout: Melissa Gerber

6 Orchard Road, Suite 100
Lake Forest, CA 92630
quartoknows.com
Visit our blogs at quartoknows.com

Printed in China
10 9 8 7 6 5 4 3 2 1

the Joy of LETTERING

A CREATIVE EXPLORATION OF CONTEMPORARY hand lettering, TYPOGRAPHY & Illustrated typeface

GABRI JOY KIRKENDALL
JACLYN ESCALERA

TABLE OF Contents

YOU CAN FIND STEP-BY-STEP TUTORIALS FOR ALL OF THE PROJECTS SHOWN IN THE INSPIRATION GALLERY—PLUS MORE—AT WWW.QUARTOKNOWS.COM/PAGE/LETTERING.

INTRODUCTION

There is something for everyone in *The Joy of Lettering*! Whatever your skill level or experience, we invite you to join us on a creative journey to try new ideas, hone your skills, and develop your own unique style.

In the following pages you'll learn the essentials for building a foundation in the art of lettering. From unique and ubiquitous typography styles to illumination, discover how to create letters using a variety of materials and media thanks to helpful artist tips; professional instruction; and easy-to-follow, step-by-step tutorials.

Like any other art form, hand lettering is unique to its creator. No one else will ever letter the same way as you. Likewise, you will never perfectly duplicate the exact styles in this book—nor should you aspire to! The letters that come from your own hand are true to you, so embrace their unique character and quality. The more you practice, the more you'll see your own style emerge and flourish.

Happy lettering!

This book has been divided into four sections to help guide you in your lettering and typography exploration:

STYLIZED TYPOGRAPHY

Stylize letters in a variety of styles and themes.

LETTERING TECHNIQUES

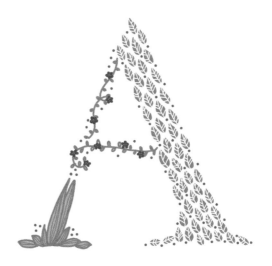

Discover new techniques and tools to help broaden your skills.

LETTERING WITH ALTERNATIVE MEDIA

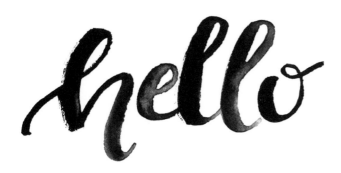

Learn to letter using non-traditional tools and materials.

LETTERING SURFACES & PROJECTS

Take your lettering to the next level through creative step-by-step projects.

ELEMENTS *of* LETTERS

Letters are a visual representation of our voice—both through the words we choose and the style of the letters or typography we employ. A letter is essentially a glyph that represents a sound, rather than an object or idea. They must be combined for their meaning to be made clear. Typography comes in many different forms, which are generally grouped into families that share similar elements.

COMMON STYLE ELEMENTS

There are four main types of letters: serif, sans serif, lowercase, and uppercase.

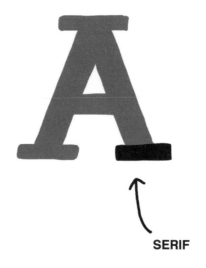

SERIF

SERIF—GREEK FOR "FOOT"

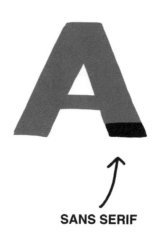

SANS SERIF

SANS SERIF—NO FEET

LOWERCASE

UPPERCASE, OR CAPITALS

Shown here are the general terms for different parts of letters. Why is this important? Because it allows you to experiment with forms and even create your own fonts!

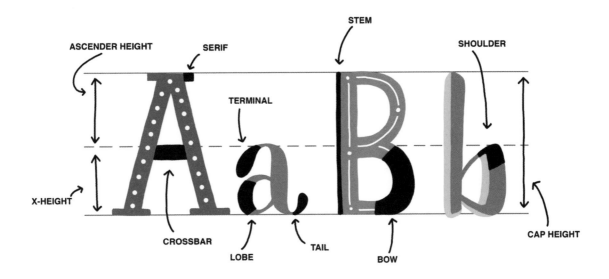

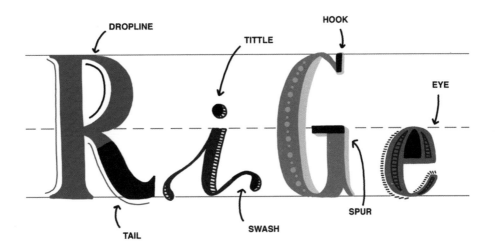

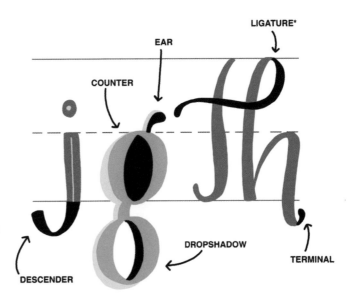

AN ILLUSTRATED HISTORY of WRITING

Humans write to communicate across distance and time, to be heard, and to record that we exist. Since the birth of writing, we've used it for commerce, poetry, stories, histories, and so much more. It is one of the most versatile art forms in existence. So how did it all start?

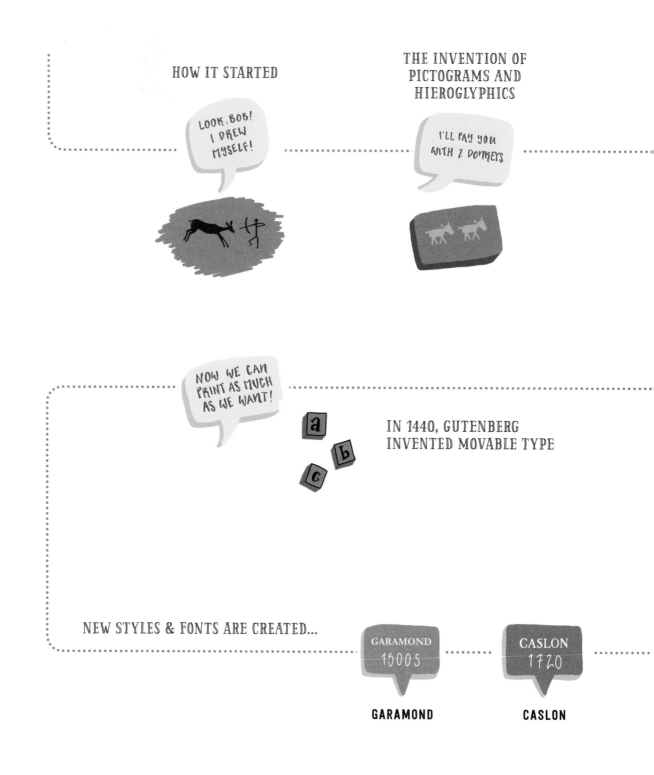

HOW IT STARTED

LOOK, BOB! I DREW MYSELF!

THE INVENTION OF PICTOGRAMS AND HIEROGLYPHICS

I'LL PAY YOU WITH 2 DONKEYS

NOW WE CAN PRINT AS MUCH AS WE WANT!

IN 1440, GUTENBERG INVENTED MOVABLE TYPE

NEW STYLES & FONTS ARE CREATED...

GARAMOND 1500S
GARAMOND

CASLON 1720
CASLON

BUT ISSUES AROSE...

SO THE PHOENICIANS
CREATED PHONOGRAMS

I THOUGHT I WAS GETTING 2 OXEN... NOT 2 DONKEYS!

DUDE, THOSE ARE TOTALLY DONKEYS. I AM GREAT AT DRAWING!

NOW THIS SYMBOL STANDS FOR A SOUND, NOT A THING

$a = (ah)$

↑ VELLUM

LATER, MEDIEVAL
SCRIBES HAND WROTE
BOOKS ON VELLUM
(ANIMAL SKIN)

THEY'RE ALL "E"S! SEE?

E Ɛ Σ

THE ROMANS STARTED
EXPERIMENTING
WITH DIFFERENT
RECOGNIZABLE STYLES
OF WRITING

BASKERVILLE 1760

COPPERPLATE 1901

GILL SANS 1928

HELVETICA 1957

THE MODERN
DAY AND
REBIRTH
OF HAND
LETTERING

BASKERVILLE **COPPERPLATE** **GILL SANS** **HELVETICA**

STYLIZED TYPOGRAPHY

Lettering inspiration is all around, from vintage posters and advertisements to natural textures and motifs. Over the ages, lettering styles have evolved and transformed from hieroglyphics and early traditional letterpress to mid-century modern sans serifs and casual script fonts.

You don't need a great deal of artistic expertise to experiment with stylizing typography. As you'll see in the pages that follow, all you really need is a little imagination. With just simple tools, such as pens and colored pencils, you can create lettering in an endless array of styles and themes.

In this section you'll find colorful examples, instruction, and helpful tips for exploring 10 different styles of lettering. But don't stop there! Remember, there are endless styles and themes to explore as you experiment with stylized typography.

How about rustic, industrial, art nouveau, Gothic, or arabesque? Whatever style you choose, study its defining features and characteristics, and then explore ways to implement those features in letterforms.

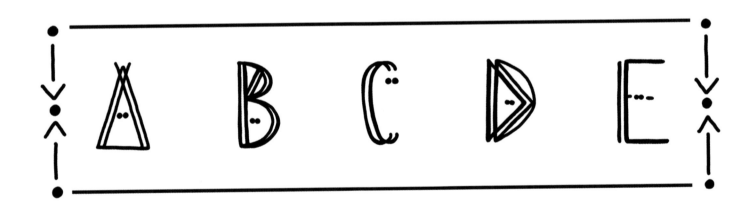

Here is a peek at the 10 different styles demonstrated in this section. After exploring these, try your hand at rendering other styles of typography.

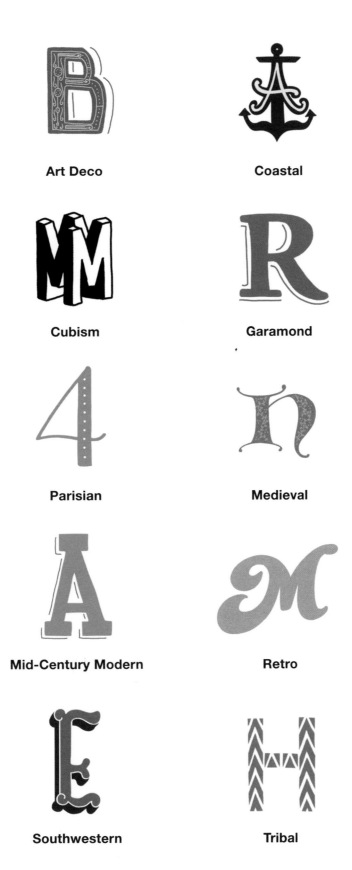

Art Deco

Coastal

Cubism

Garamond

Parisian

Medieval

Mid-Century Modern

Retro

Southwestern

Tribal

ART DECO

Originating in the 1920s, the Art Deco design movement is most often associated with the decadence and frivolity of the Roaring Twenties, known best today through works such as *The Great Gatsby* by F. Scott Fitzgerald.

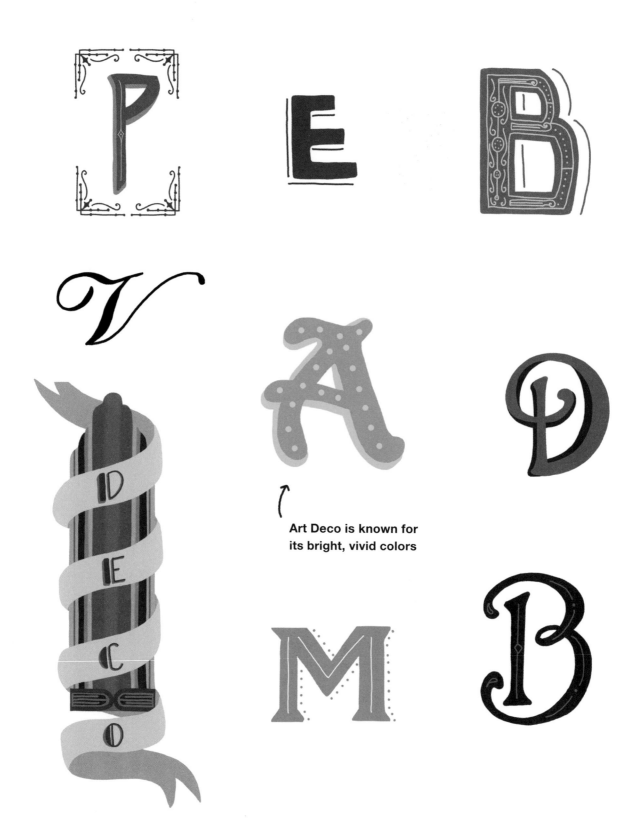

Art Deco is known for its bright, vivid colors

Elegant
ornamentation is
a unique facet of
the style

Another fun aspect
of the Art Deco
movement is the
unique style of
flourishes. These are
great embellishments
for your lettering work!

Defining
CHARACTERISTICS

- SIMPLE, CLEAN SHAPES
- GEOMETRIC ORNAMENTATION
- SWEEPING CURVES
- BOLD LINES

COASTAL

Coastal lettering evokes life along the ocean. Just imagine sea salt in the air and sand between your toes as you allow your pen to drift across the page. This style of lettering is casually beautiful. Any elements that are related to the ocean and beach are welcome. Think palm trees, sea stars, waves, and nautical details, which can be incorporated into your letters in unique and unexpected ways.

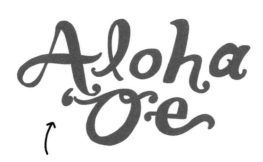

Combination of cursive and ornate lettering alludes to the rise and fall of the ocean

Mimics early nautical fonts

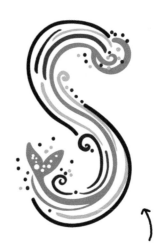

Imitates waves and a fish tail emerging from the surf

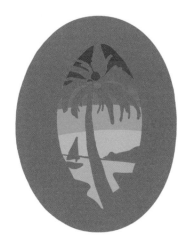

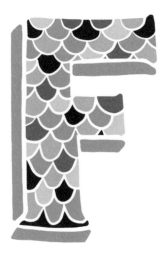

You can incorporate a variety of textures and patterns

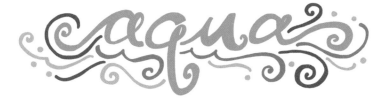

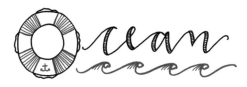

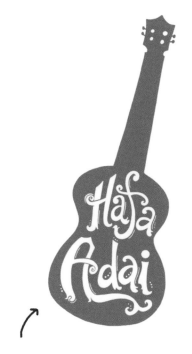

Hafa Adai is an informal Chamorro greeting that means "Hello."

17

CUBISM

Cubism is a movement that evolved during a period of artistic innovation between 1907 and 1914. Viewed as minimalistic and Avant Garde, the style was popularized by Pablo Picasso, particularly through works such as *Guernica*.

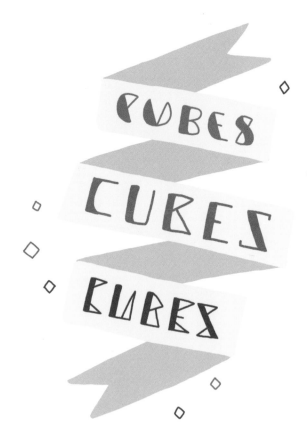

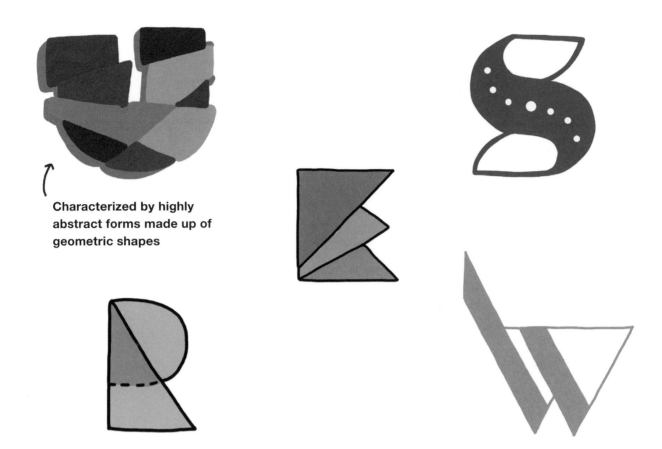

Characterized by highly abstract forms made up of geometric shapes

A great way to approach Cubism is to first sketch the basic letter, and then divide it into geometric shapes.

1. 2. 3.

GARAMOND

Garamond is the classification given to a group of old-style typefaces. This style of typography was developed as a more elegant and readable type for early printing.

The Garamond type family is versatile because of its many weights, italics, ornaments, stylistic alternatives, and ligatures.

Garamond is elegant without being overly ornate

History of GARAMOND

Modern Garamond fonts are modeled after a set of skillfully crafted letterpress punches designed by French publisher and type designer Claude Garamond in the early 1500s. Garamond punches continued to evolve as time passed. One notable version incorporated work by Jean Jannon in the early 1600s. In 1825, Jannon's version of Garamond was found after being lost for nearly 200 years. It was mistakenly attributed to Claude Garamond, which is how it received its name.

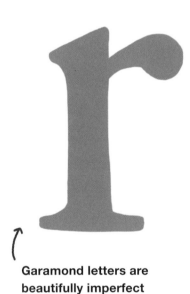

Garamond letters are beautifully imperfect

Serifs are soft

N

n

Letters delicately pucker and bloat

Lowercase top serifs curve to join the main strokes

n

t

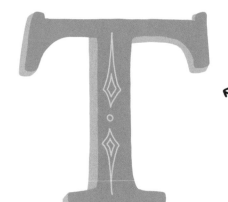

T

On the uppercase "T" the top left serif is slanted and the top right serif is straight

LIGATURES

A ligature is made from two or more letters that are joined together. Early ligatures can be found in handwritten manuscripts—they saved scribes writing time. Once printing was developed, ligatures were used to correct spacing problems. Ligatures are a beautiful blend of form and function. Below, the "s" and "t" are joined, as are the "V" and "i."

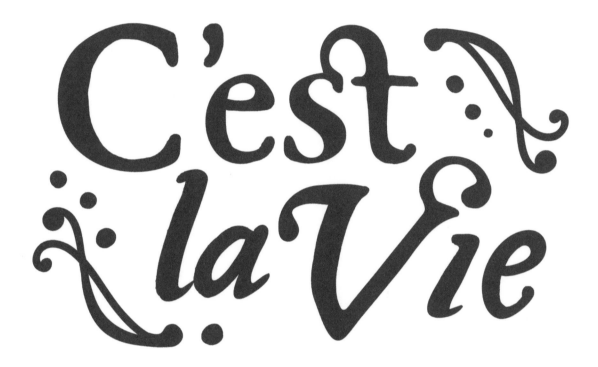

Defining **CHARACTERISTICS**

- BRACKETED SERIFS
- TIPPED AXIS
- MINIMAL CONTRAST BETWEEN THICK AND THIN STROKES
- GRACEFULLY CURVED LINES
- ROUNDED TAILS

PARISIAN

In the early 1900s, applying geometric form to existing styles of typography became increasingly popular. This change was the birth of the Parisian style, which invokes images of tall, stately buildings and elegance and opulence. Parisian is a child of the *Belle Époque* ("Beautiful Era")—a period from the 1870s to 1914 in Western Europe known for its prosperity, innovations, culture, and arts. This style is also associated with the beginning of the Art Deco movement.

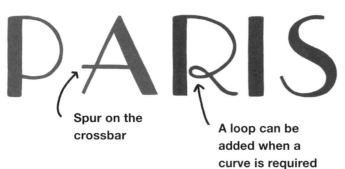

Spur on the crossbar

A loop can be added when a curve is required

Extra long ascender

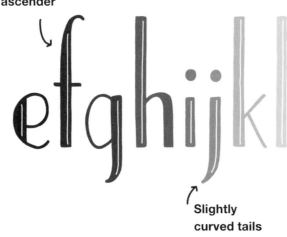

Slightly curved tails

Loop at the end of a curve

Loop

Stylized, slightly curved line

Defining CHARACTERISTICS

- STRAIGHT, STRONG LINES
- JUXTAPOSITION BETWEEN THICK AND THIN LINES
- WIDE UPPERCASE LETTERS WITH CURVES
- TALL LOWERCASE LETTERS WITH STRAIGHT ASCENDERS

MEDIEVAL

In medieval lettering styles, the character of the writing is primarily determined by the tools used. Medieval scribes carved their own pens from feathers or reeds. These unique tools, along with the necessity to write quickly on vellum paper, established the art of medieval calligraphy, with its rounded, elaborate lettering and carefully illustrated pictures and flourishes. Monasteries have produced the most well-known examples of medieval lettering, such as *The Book Of Kells*.

This style uses lines and sharp decorative elements

Employs curved, swooped serifs and tails

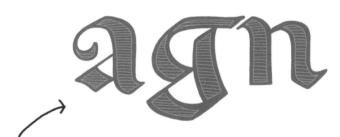

Lowercase letters display a combination of sharp edges and elegant curves

Defining **CHARACTERISTICS**

- SWOOPS AND FLOURISHES
- TAILS AND SPURS
- SWOOPING, STYLIZED SERIFS
- DECORATIVE TITTLES
- SHARP, SQUARE EDGES RESULTING FROM THE CUT OF THE NIB OR END OF THE PEN

MID-CENTURY MODERN

The mid-century modern graphic and design movement emerged in the mid-20th century and spans a time period roughly from the mid-1930s to the 1960s. This design trend utilizes a clean, simple aesthetic with minimal ornamentation, geometric shapes, and bold patterns. Initially a celebrated movement in furniture, architecture, and interior design, the style has reemerged over the past decade.

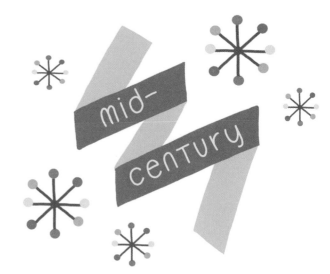

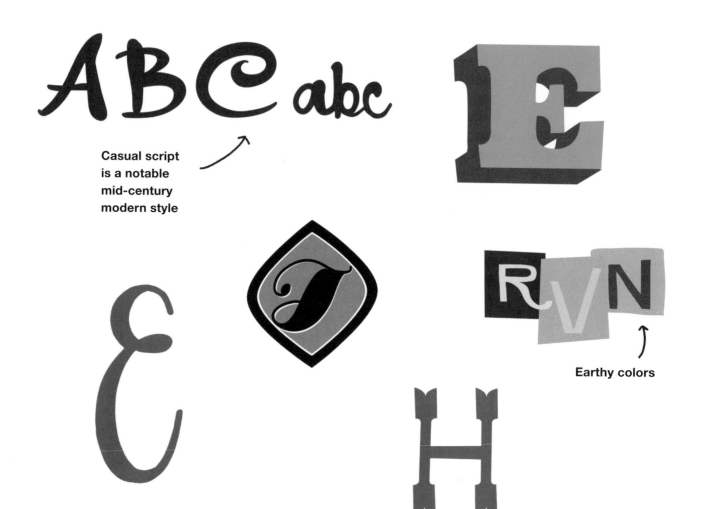

Casual script is a notable mid-century modern style

Earthy colors

Geometric
curves

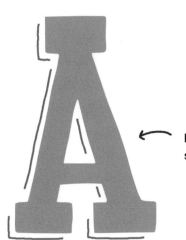

Both slab serif and sans
serif fonts are typical

Defining
CHARACTERISTICS

- CASUAL SCRIPTS WITH WEIGHTED ASCENDERS
- THICK, GEOMETRIC SANS SERIF FONTS
- ASYMMETRICAL APEX HEIGHTS AND DANCING BASELINES
- ASKEW SHAPES

RETRO

Retro style takes you straight back to the glory days of the '40s and '50s. This style evolved from the post-war boom and is most often associated with signs and advertising from big-name brands such as Coca-Cola® and Pegasus™. Retro lettering evokes images of optimism, Americana, and destinations like Route 66.

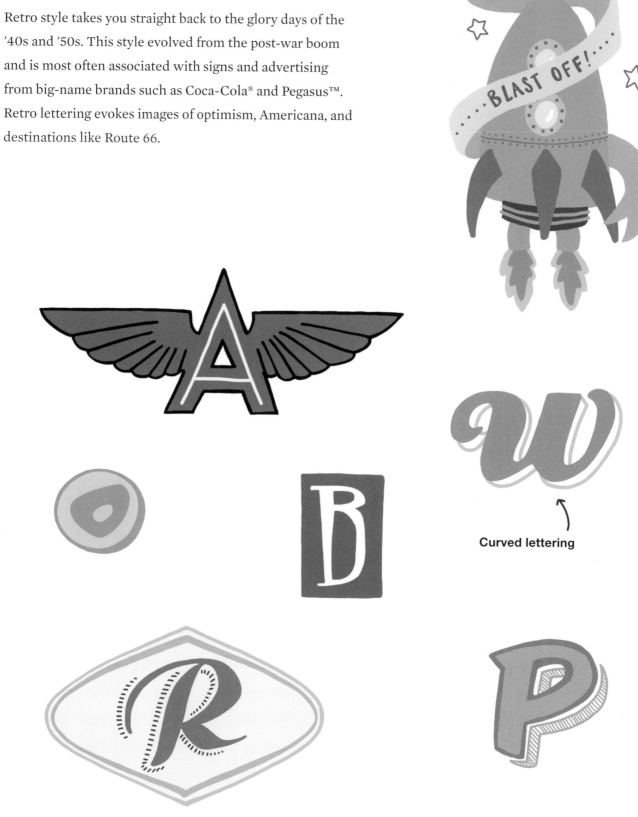

Curved lettering

Geometric shapes
with thick lines

Retro is all about going big with lights, neon, flashing arrows, and mid-century bling. The sky's the limit: serif, sans serif, curves, 3-D, stars, and space-age designs—it's a great style to have fun with!

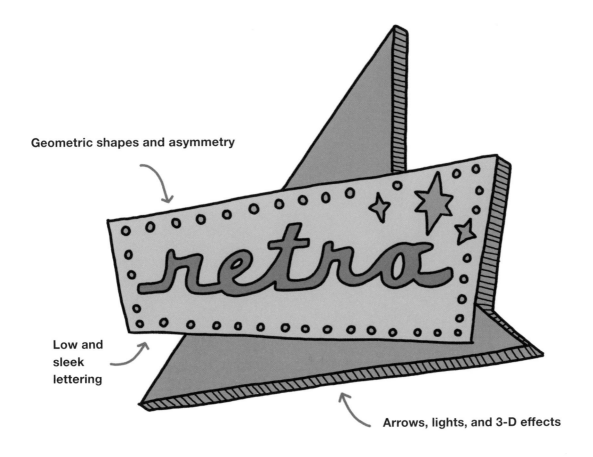

Geometric shapes and asymmetry

Low and
sleek
lettering

Arrows, lights, and 3-D effects

SOUTHWESTERN

Southwestern lettering styles evoke the days of the Wild, Wild West. This style is often boldly exhibited across many famous Western film posters. Other influences of this style include the rustic, yet intricately hand-lettered signs from early Southwestern oil boomtowns—and the conspicuous lettering donned across "wanted" posters for notorious outlaws across the West.

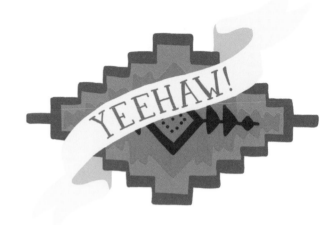

These decorative embellishments are reminiscent of embossed leather

Outline your letters to give them extra visual interest

← Ornamental, stylized serifs

S W I 0 2 6
7 H g C M

Southwestern lettering is all about
elaborate details and flourishes →

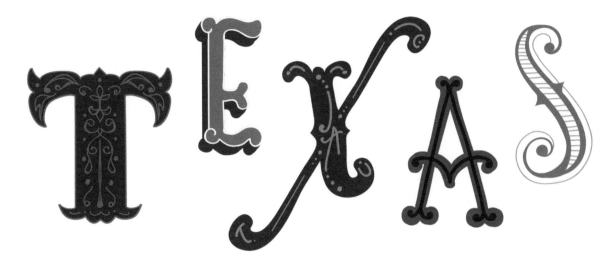

31

TRIBAL

Tribal-style lettering can be described as any kind of lettering or embellishment that draws inspiration from recognizable motifs related to native cultures and designs—from Polynesian and Arctic to Native American and African. The most commonly used elements include arrows, feathers, and geometric shapes.

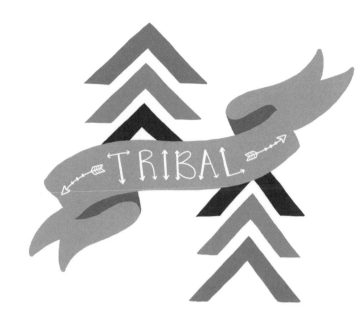

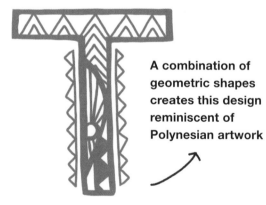

A combination of geometric shapes creates this design reminiscent of Polynesian artwork

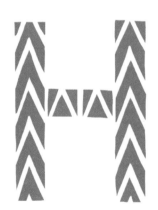

An arrow makes a dramatic background for lettering

Below is a great example of how you can incorporate this lettering style into your artwork. The dream-catcher design connects letters and feathers to produce an illustrative touch. Lines, arrows, tiles, and decorative marks embellish the lettering, and the juxtaposition between cursive and non-cursive lettering makes the design more visually stunning.

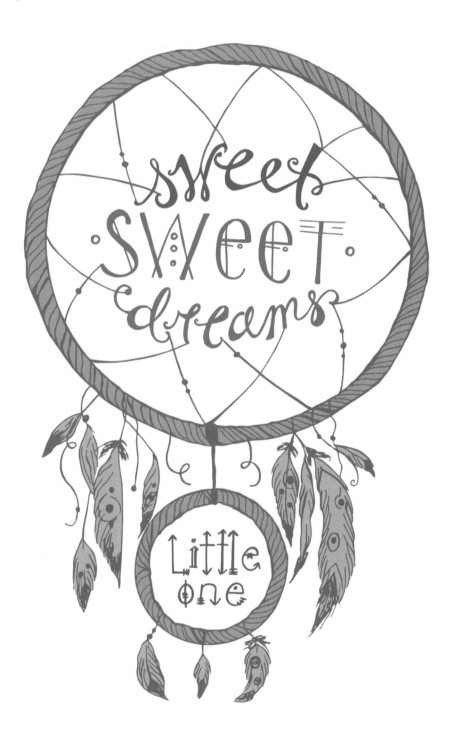

LETTERING TECHNIQUES

Lettering is an ancient and powerful art form. Today's modern lettering artists follow in the footsteps of age-old traditions reminiscent of the days of monks hand lettering and illuminating manuscripts—centuries before the invention of printing!

Today, the means and methods of producing beautiful, expressive lettering are endless. From pencils and markers to pens and paints, or even crayons and chalk, you can use just about any mark-making tool to craft pretty letters and words. You can even take your lettering work into the digital sphere by scanning or photographing the finished product for use in a wide array of unique and creative applications.

The techniques and tools in this section are by no means an exhaustive look at the myriad available options. Use these ideas as a guide to get started, and don't be afraid to branch out and experiment with other lettering tools and techniques.

A GREAT WAY TO PRACTICE LETTERING WITH DIFFERENT TOOLS AND IN DIFFERENT STYLES IS TO CREATE A LETTERING SAMPLER. FOR EXAMPLE, CHOOSE A WORD AND WRITE IT OVER AN OVER IN AS MANY STYLES YOU CAN. ON THE NEXT PAGE, I USED THE WORD "CREATE," BUT FOR A FUN TWIST I WROTE IT IN MANY LANGUAGES.

create Créer CRÉER JOKOLEU ERSTELLEN erstellen

CREATE CRIO YARATISH LUODA BÚA Looma create CREARE CREATE CR E U

Krijoj

CREATE CREATE SORTU LUMIKHA erstellen créer

CHRUTHÚ UKUDALA

SORTU CREATE KUJENGA

IZVEIDOT create CRÉER

CREU CREËREN

WAIHANGA KRIJOJ

CREATE Creu SORTU

CHRUTHU CREAR CREATE
create

STWÓRZ SKABE teremt

CRÉER CREATE UKUDALA

KREYE CREATE TEREMT create

CALLIGRAPHY

Cursive script was developed for writing more quickly and efficiently. While the style was developed during the Middle Ages, it really had its heyday in the 18th and 19th centuries. Cursive calligraphic style is defined by a combination of thin and thick lines formed by the tip of a pointed nib or quill. Each letter connects to the next by a line, known as a joiner, which creates an easy flow across all letters.

cursive

THICKER DOWNWARD STROKES

abcdef

JOINERS

THINNER UPWARD STROKES

When you're using a calligraphy tool for cursive writing, remember to gently push down for the thicker down strokes and lightly pull up for the thin strokes. It's a good idea to practice gently pushing and pulling with the pen nib on a separate sheet of paper before getting started. Try the simple technique shown below for creating the calligraphy look with a regular writing implement.

c'est la vie *c'est la vie*

Start with simple cursive writing. Add additional lines to indicate the
 thicker down strokes.

c'est la vie

Fill in the down strokes.

c'est la vie *c'est la vie*

c'est la vie

c'est la vie *c'est la vie*

c'est la vie

c'est la vie

c'est la vie

c'est la vie

c'est la vie

c'est la vie

There are many different styles of cursive, which is one of the reasons why the style remains so popular today. Practice this lettering technique in a variety of styles to find the one that suits you best.

FLOURISHES

Calligraphy flourishes are found all throughout history. Each period has flourishes that complement its own unique style of lettering. Traditional calligraphy flourishes have a specific set of rules that require patience and practice to master; however, modern-day flourishes are less about rules and more about your own aesthetic style and taste.

Here are some fun examples of simple flourishes and ornaments you can use to embellish your lettering.

Try this simple step-by-step process to create some truly beautiful flourishes. After you have practiced the basics, you will be ready to create many beautiful and unique flourishes of your own!

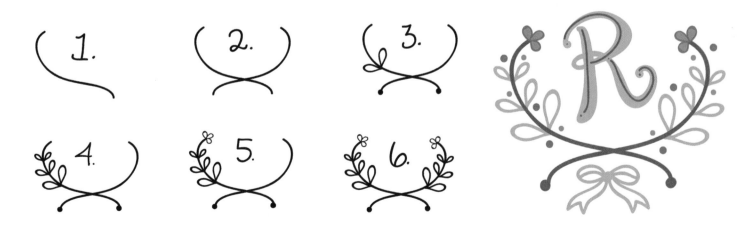

3-D TECHNIQUES

Three-dimensional lettering techniques give letters on a two-dimensional surface the illusion of depth, as well as width and height. This is a great skill to master that can give your art extra personality and magnitude. It adds a delightful visual "pop" on both paper and computer screens. Modern 3-D lettering can be rendered digitally; however, it is gratifying and useful to perfect by hand. With a little practice, you will be amazed by all the different ways you can incorporate 3-D lettering into your work. This versatile technique can be done in any font style. Here are a few different ways to create 3-D lettering with serif, script, and sans serif letters.

This letter looks like a vintage letterpress lead letter

In this is a serif example, notice that the light source comes from behind the letter

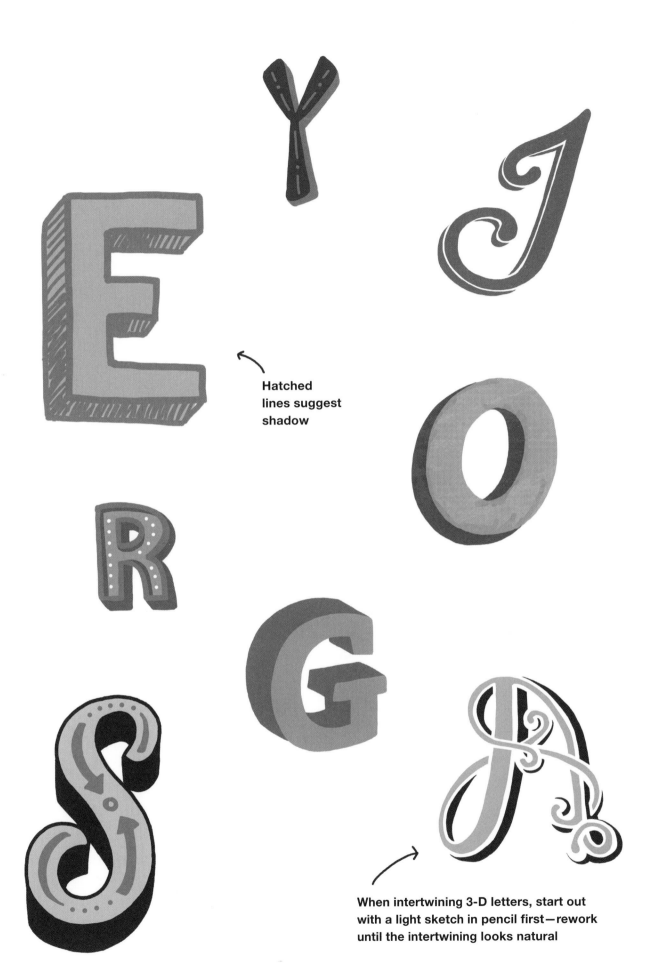

Hatched
lines suggest
shadow

When intertwining 3-D letters, start out
with a light sketch in pencil first—rework
until the intertwining looks natural

Here's an easy step-by-step tutorial to help get you started with your own 3-D lettering. Give it a try!

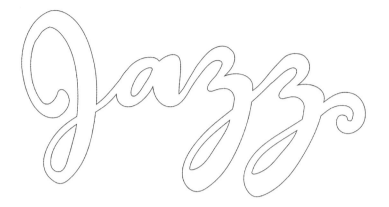

STEP ONE

Start by sketching the letters. I chose a script font for a modern twist on a traditional style of type.

STEP TWO

Draw a bubble around your letters, and fill it in with a medium shade—you can use any art tool, from colored pencil or marker to paint or inks.

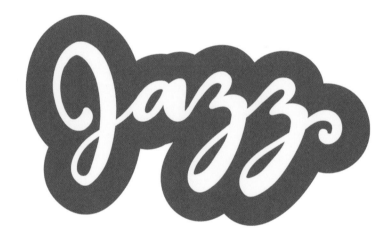

STEP THREE

Imagine in which direction the sun would be shining on your letters. Follow the lines around the letters on the side that is opposite from your imagined sun. Fill this area in with a dark shade.

STEP FOUR

Add white lines around the dark curves of the shading to create even more depth.

STEP FIVE

After completing the shading, you can add extra flourishes if you like—or in this case, some extra "jazz!"

ILLUMINATED LETTERING

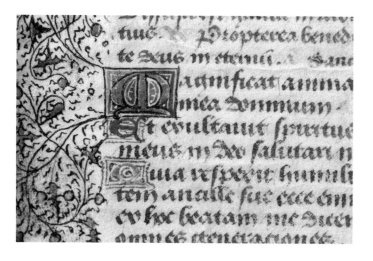

The term "illuminated" means "to be filled with light." The term "illuminated lettering" was originally used to describe the gold-leaf embellishments in medieval manuscripts, which caused the pages to reflect light and appear to glow.

Illumination also refers to the illustrations and decorations drawn around the letters. For many in the Middle Ages, most of whom were illiterate, the illuminations brought the stories to life.

In modern interpretations, artists use illuminated lettering as an opportunity to showcase their illustrative talents.

Take a peek at these illuminated examples, and then turn to page 46 to follow the easy instructions for different techniques to create your own!

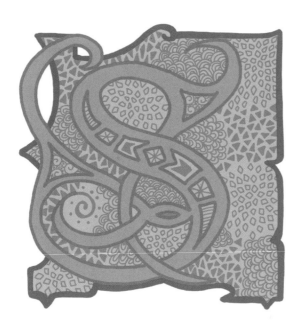

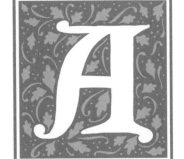

ARTIST'S TIP

A GREAT WAY TO GET STARTED WITH ILLUMINATED LETTERING IS TO PICK YOUR FAVORITE LETTER AND CHOOSE ONE DOODLE OR DESIGN. THEN PRACTICE COMBINING DIFFERENT ILLUSTRATIONS WITHIN A SINGLE ILLUMINATION TO TAKE IT TO THE NEXT LEVEL!

ANIMALS

Follow these easy step-by-step instructions to create a whimsical illuminated letter. This kind of illumination is perfect for a nursery, personalized stationery, or even a home office.

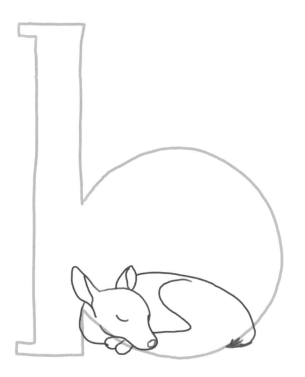

Lightly pencil in guidelines for the letter. Then roughly outline your chosen animal. I chose a sweet, sleeping fawn.

Start to add color to your animal by laying down a base color. For this fawn, I used a medium brown shade.

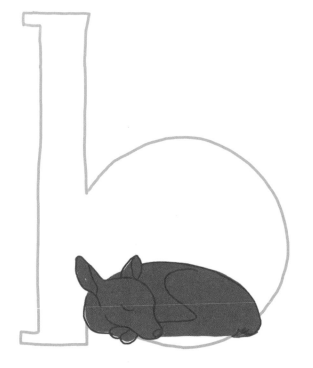

STEP THREE

Add shading to the animal, and erase any pencil marks. Then use an opaque white pen to add contour lines and finishing details.

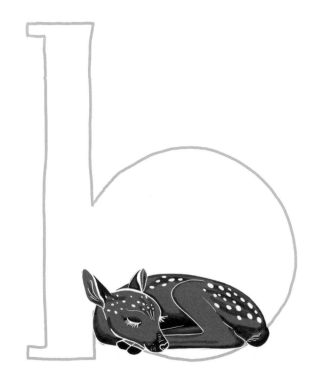

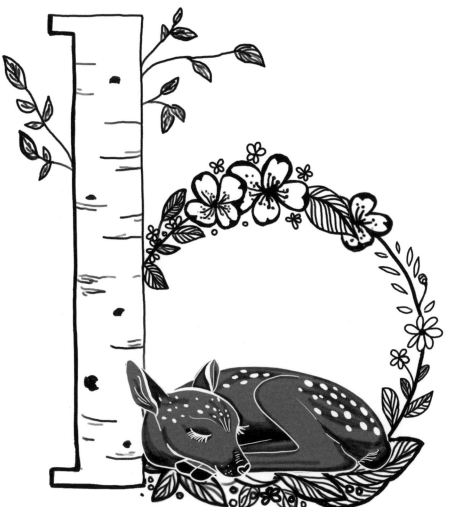

STEP FOUR

Next sketch the embellishments and illumination details for the rest of the letter. I chose to illuminate my letter with a tree and floral elements. Use a fine-point pen to outline your drawing and add detail work. Then erase your pencil marks.

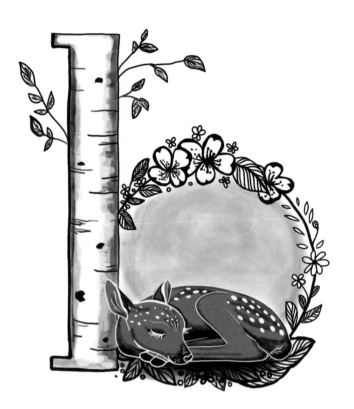

Add color and shading to the background. I filled the center of my letter "b" with dusky blue and added a dark green shadow to the foliage beneath the fawn. I also added some gray shading along the stem of the "b."

STEP SIX

Add additional pops of color and shading to finish the illumination.

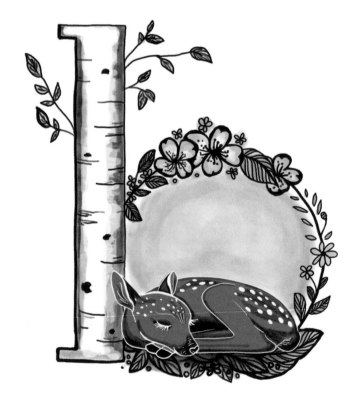

48

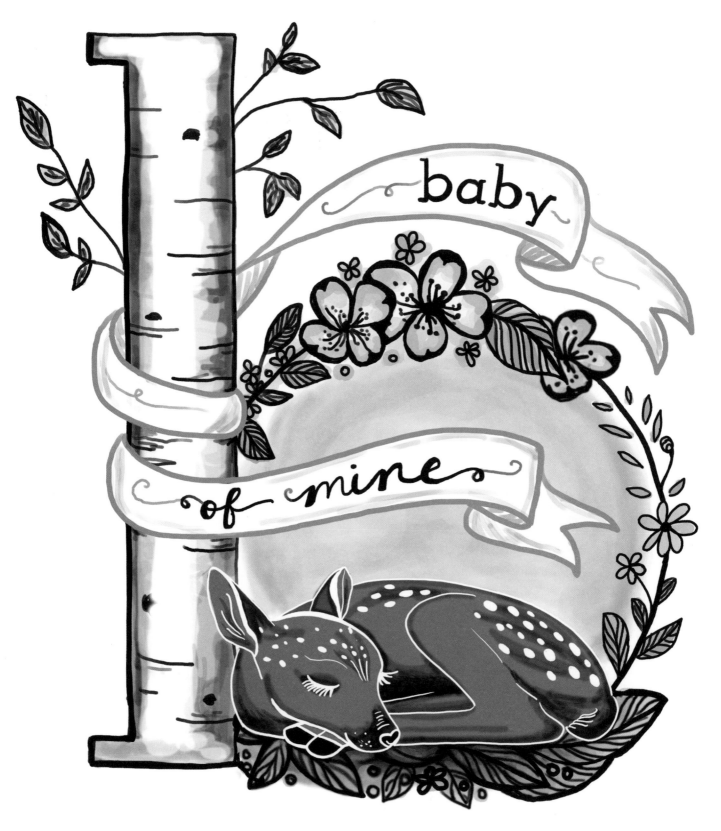

STEP SEVEN

If you like, add in additional lettering elements or words with a ribbon banner.

BIRDS

Birds are a common motif in illumination. In this step-by-step tutorial I'm illuminating the letter "P" with a peacock. Follow along, and then try your own version. How about a parrot or parakeet, or a quail with the letter "Q" or a rooster with the letter "R"?

STEP ONE

Lightly sketch the letter. I added simple design elements to mine that mimic the shape of peacock feathers.

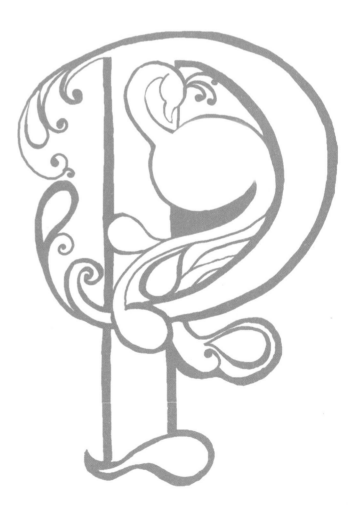

STEP TWO

Think about how you would like to fit the bird into the letter. If need be, try a couple of variations on scrap paper. Sketch in the bird, and erase any areas that overlap.

STEP THREE

Add additional detailing and a frame around the letter.

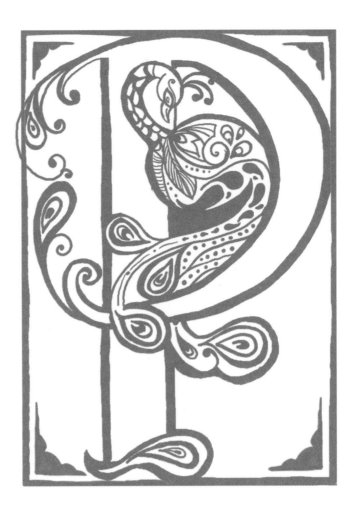

STEP FOUR

Trace over your sketch with a fine-point metallic pen, and erase your pencil marks.

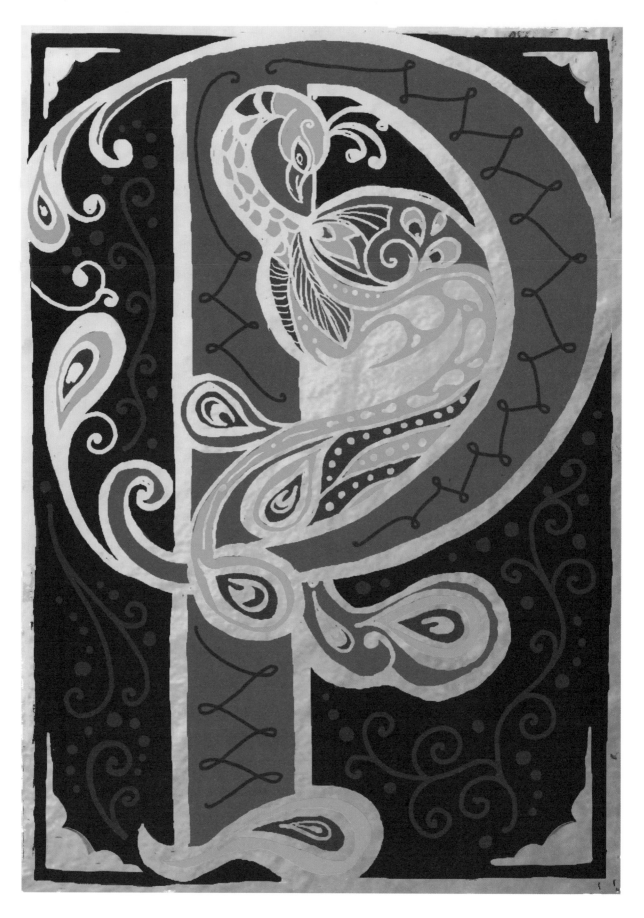

STEP FIVE

Add color and elegant flourishes to finish the illumination.

FLOWERS

You can use beautiful flowers for stunning effects in illuminated lettering.

STEP ONE

Trace or sketch the outline of the letter.

STEP TWO

Begin to sketch the illustrations. I usually start at the bottom and work my way up when I am drawing plants, since that's how they grow. Erase and redraw as you go.

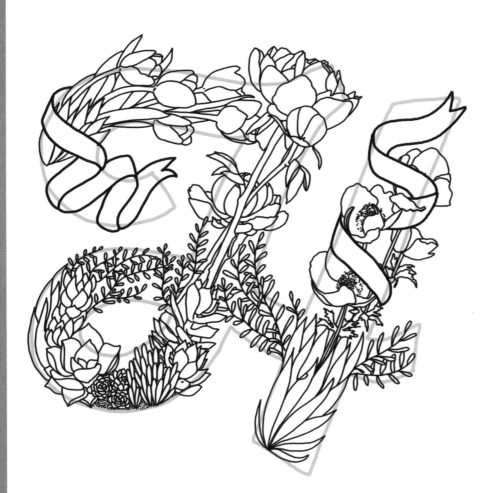

STEP THREE

Add additional elements to fill out the letter, such as a banner or other botanicals. Once the illustrations are complete, ink the outlines. I like to ink the outlines first, and then add additional details and shading last.

STEP FOUR

Add details to complete the design, such as veins on the leaves.

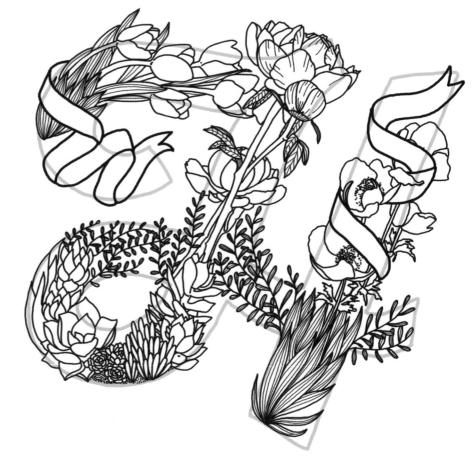

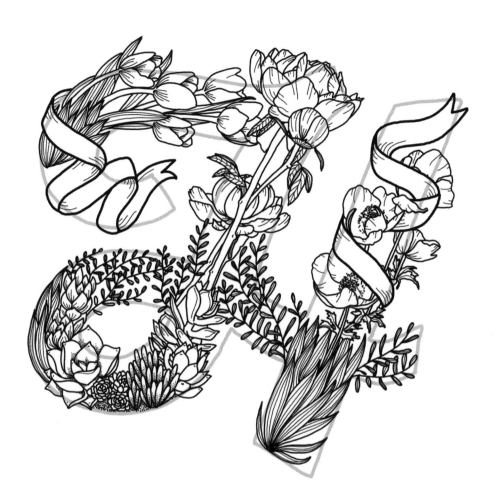

STEP FIVE

Continue to add detail and shading to give the flowers depth. Fill in any spots that are blank to make the silhouette of the letter full and true.

STEP SIX

When you're happy with the details, erase the pencil marks.

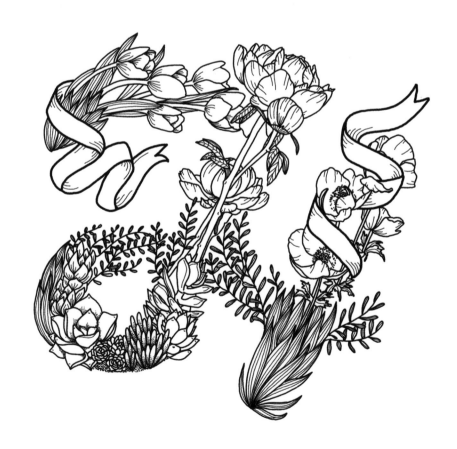

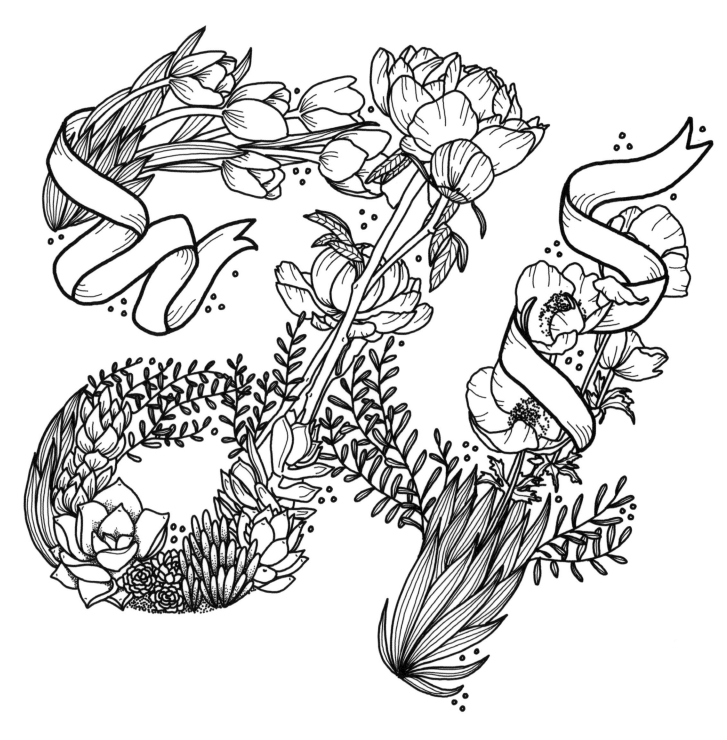

STEP SEVEN

With the pencil lines gone, review your illumination for any empty spaces. I added several sets of dots throughout my letter in open spaces to add visual interest and movement.

Objects

You can use just about anything to create an illuminated letter. Even the most mundane of objects can add interest.

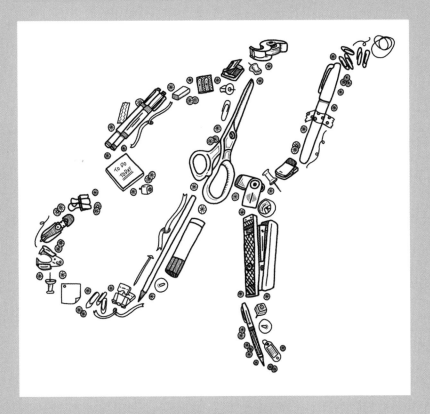

Pay attention to how your design fills the space so that you can be sure to fill the entire surface area, while keeping the shape of the letter clear.

This modern take on an illuminated letter is an example of how artists today can draw inspiration from different lettering styles and techniques.

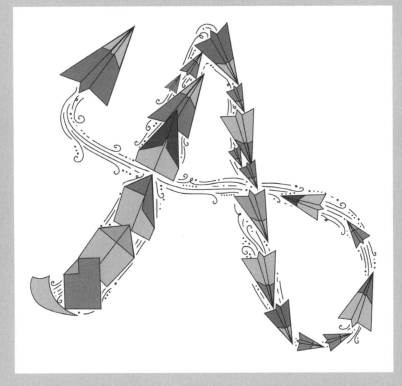

CHALK LETTERING

Chalk is a fun and versatile medium, and it doesn't require a lot of technique or experience. You can use a variety of tools, from chalk pencils, chalk pens, and chalk pastels. Chalk pastels are what we've used in this project.

MATERIALS

- Chalkboard
- Chalk pastels
- Water
- Rag
- Cotton swabs

STEP ONE

Start with a simple sketch of the letter or letters.

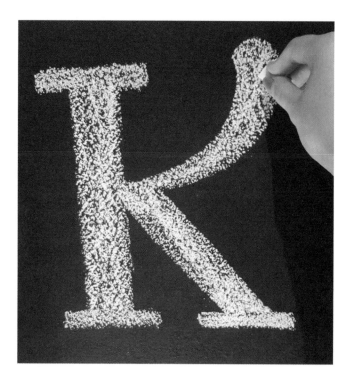

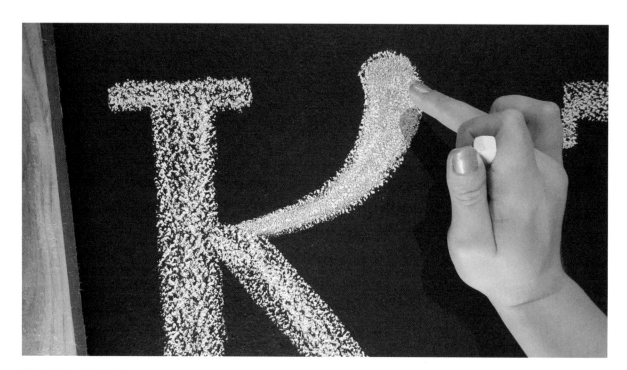

STEP TWO

To create a smooth, even texture, use your finger to blend the chalk.

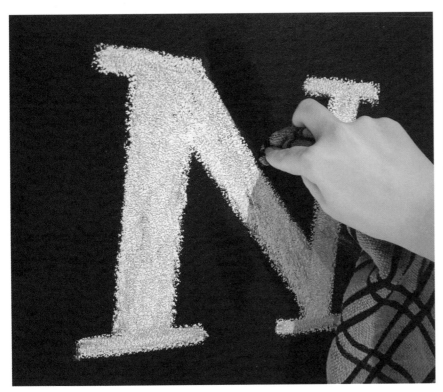

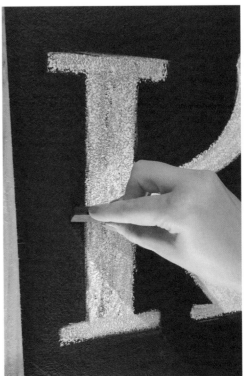

STEP THREE

Use the tip of a damp rag to clean the edges of letters. To make your letters really "pop" off the chalkboard, use a black chalk pastel to outline them. You won't see it from far away, but it creates lovely contrast.

STEP FOUR

To add embellishments to your letters, use a wet cotton swab to create designs within the letter by wiping away the chalk.

NEGATIVE LETTERING

Negative space is the area around and between the subject of an image. To create beautiful negative lettering, simply form the letter or phrase with designs around the shape of the letters, rather than outlining the letter itself, so that the blank space shows the letterform.

CARPE DIEM

STEP ONE

Sketch the outlines of the letter(s). These outlines will help guide your illustrations and result in a clean impression.

STEP TWO

Begin to sketch your illustrations. I'm using a tangling/doodling style of art and drawing with a darker (softer) lead pencil to achieve contrast.

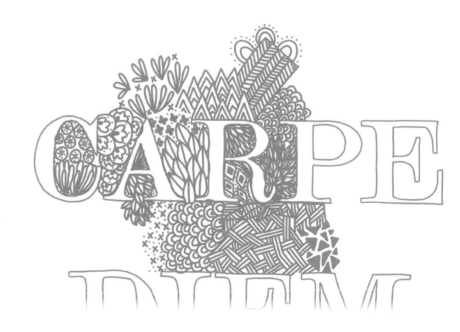

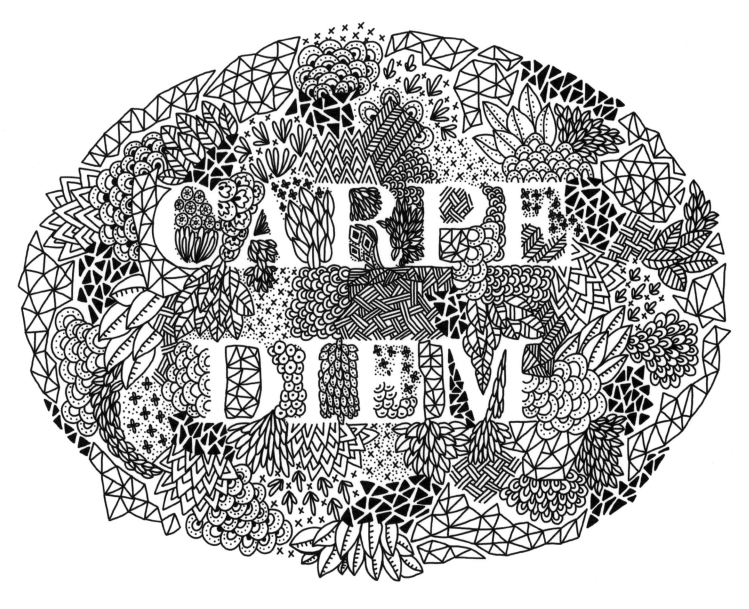

STEP THREE

Fill out your design with the doodles or illustrations of your choice. When you're happy with the look, ink over the pencil and erase all the pencils marks. Negative lettering is an easy way to achieve beautiful impact.

SHAPING

Lettering freehand can lead to lovely art; however, it can be intimidating when you are first starting out, or if you have a particularly complex design in mind. A great way to practice is to *shape* your lettering. Shaping provides a framework, or skeleton, for your letters.

STEP ONE

Start with the basic shape you'd like the letters to take, such as a circle, and draw boundaries for each word. Add the x-heights, which will determine if the letters will be straight, curved, or diagonal.

STEP TWO

Sketch the lettering. Be sure to follow the x-heights as you form each letter.

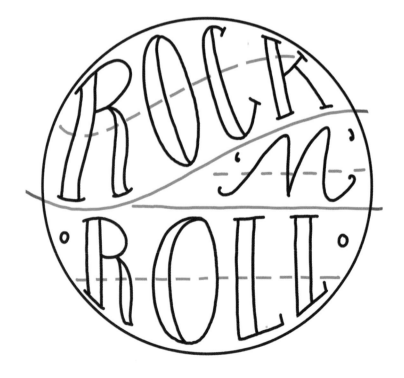

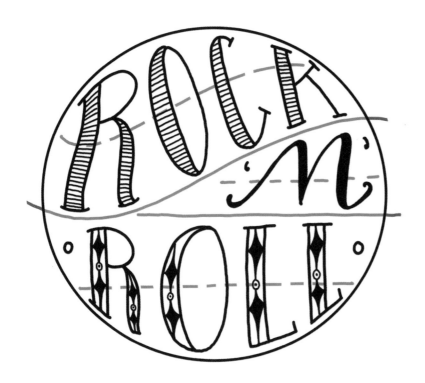

Ink over the letters, and add fun details.

STEP FOUR

Erase the pencil guidelines, and you're done! I did this fun version in shades of teal and turquoise.

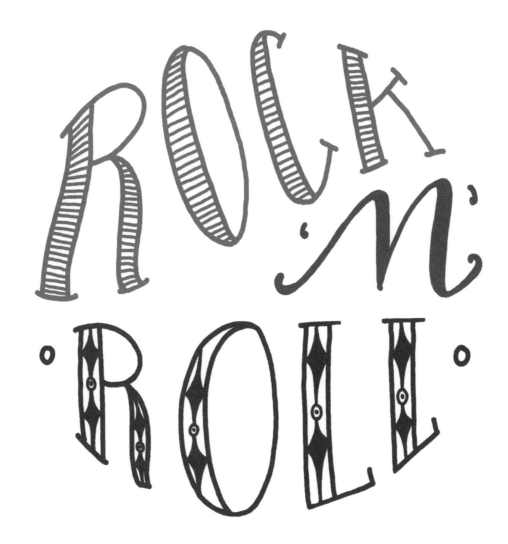

DIGITIZING LETTERING

Nothing beats developing your skills with good old-fashioned paper and a pen, but in today's modern world there also are many applications for the use of digitized lettering. Many hand letterers use design tablets to create digital lettering, but a more affordable option is to photograph or scan your work. You can use your own lettering for a plethora of fun projects, such as temporary tattoos, fabric printing, custom stationery, and more!

To get started, gather the following items: your artwork, a camera, white 9" x 14" paper, white tissue paper, a cardboard box, a box cutter, lamps or lights, a tripod, and a computer.

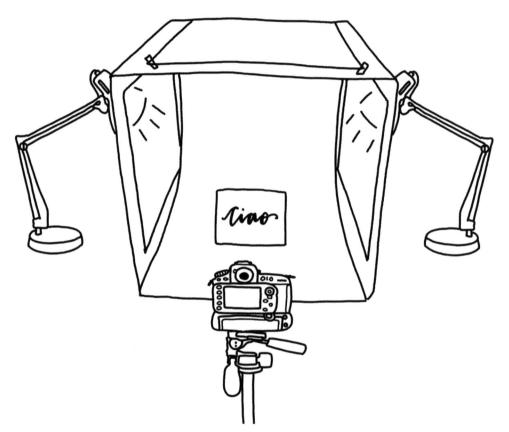

STEP ONE

Before photographing your lettering, you need to create the right conditions. The easiest way is to make your own light box. All you need is a cardboard box! Completely cut off one side with a box cutter. Then cut out large rectangles on the sides and top. Tape a piece of white tissue paper over each rectangle on the outside of the box—make sure the tape doesn't overlap the hole. Tape up a long 9" x 14" piece of printer paper so that it is the background and bottom of your light box. Now position your lighting. The best type to use are work lamps with adjustable heads. Place one on either side of the box so that they shine against the tissue paper-covered sides. If you have a third light, you can also have one shining on the top. Position your camera on a tripod in front of the box. Now you are ready to photograph your work!

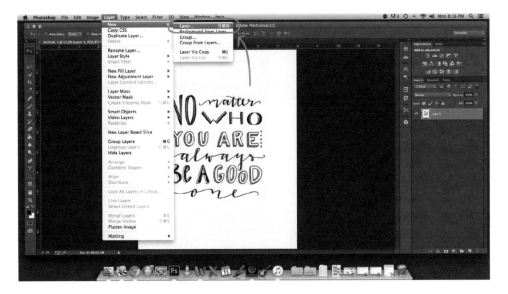

STEP TWO

Upload the photograph to your computer and open it in Photoshop® or the photo-editing software of your choice. Click on "Layer" on the menu bar, and then click on "New," and select "Layer." A "New Layer" box will pop up; click "OK."

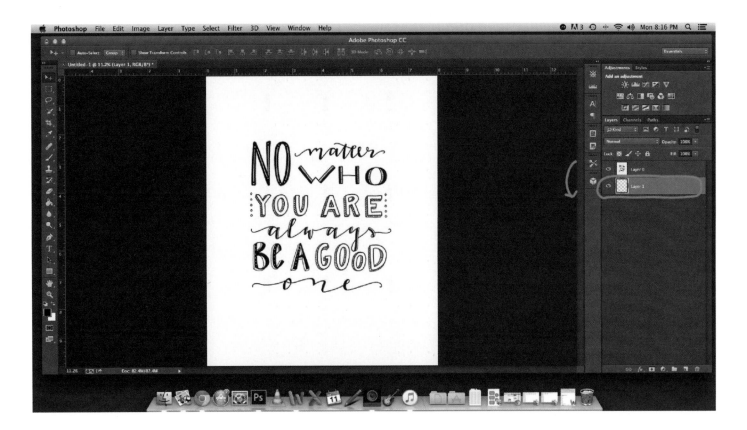

STEP THREE

Move the new blank layer beneath the layer containing your artwork.

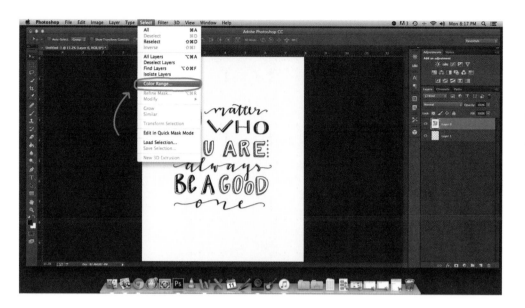

STEP FOUR

Make sure the layer with your artwork is selected. Then click on "Select" from the menu bar, and choose "Color Range."

STEP FIVE

Use the eyedropper tool that appears to select the background by clicking on any part of it. Then you can experiment with how many pixels are selected by moving the "Fuzziness" slider. Playing with this function will help you to discover what your preferred number is.

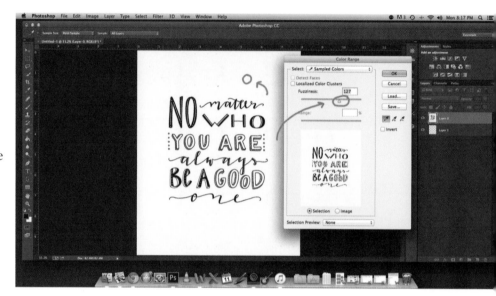

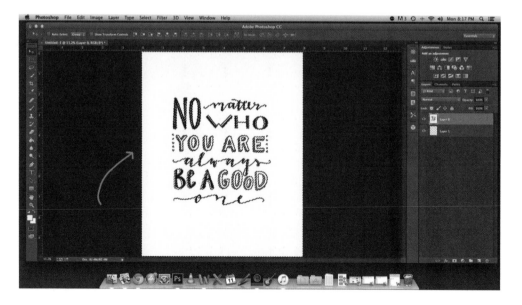

STEP SIX

After you click "OK" your screen should look like this, showing that the background color is selected.

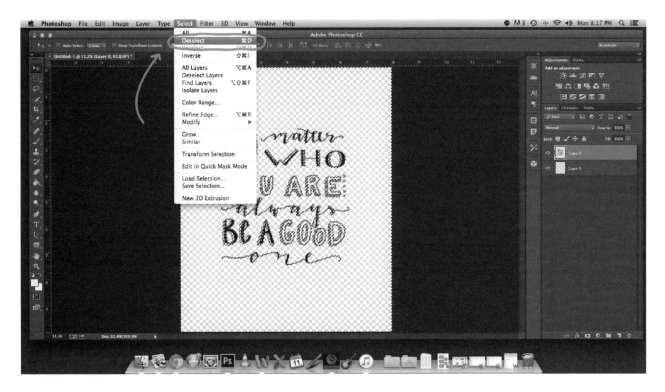

STEP SEVEN

Hit the "Delete" button on your keyboard, and watch the background color disappear. Now click on "Select" again, and choose "Deselect."

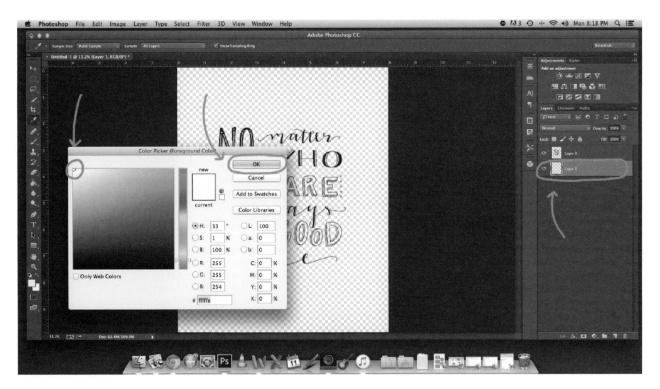

STEP EIGHT

To add a color to the background to check your work, select the bottom blank layer. Then click on the color swatch tool in the lower left-hand corner. Once the color box pops up, select a color and click "OK."

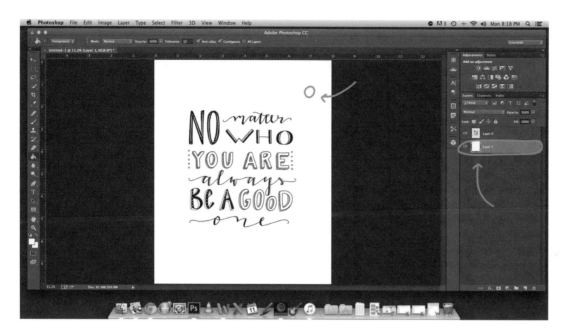

STEP NINE

Select the paint bucket tool, and then click it anywhere on the blank layer to add the new background color. I've just used white for demonstration purposes.

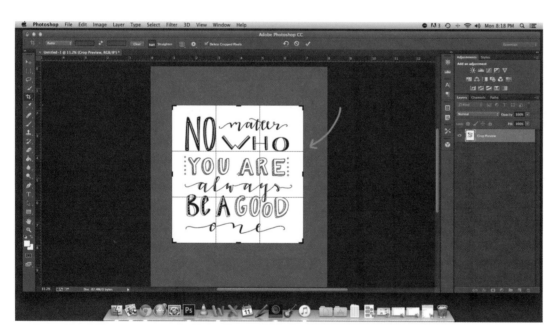

STEP TEN

You can crop your work, if you choose, by selecting the crop tool, and then manipulating the crop box when it appears over your art. Double-click on the crop box to crop.

STEP ELEVEN

If you are happy with how it looks, click on "File" on the menu bar, and then select "Save."

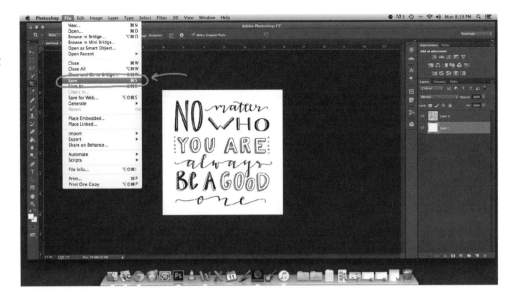

STEP TWELVE

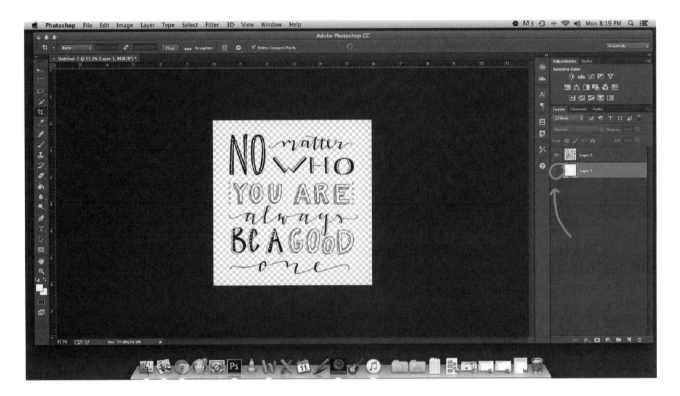

If you want to drop your work onto a different background, simply go back to the background layer and click on the little eye symbol to the left. This makes the layer invisible. Then re-save the file.

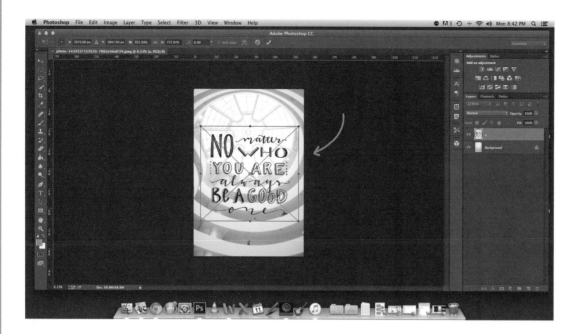

STEP THIRTEEN

To drop the artwork onto a different background, simply open the desired background in Photoshop, and then drag and drop your artwork file onto the new background. Your screen should look like this. You can re-size the artwork on the background by clicking and dragging the corners of the box.

STEP FOUTEEN

When you are satisfied, double-click on the box to place it on the background. Save your file.

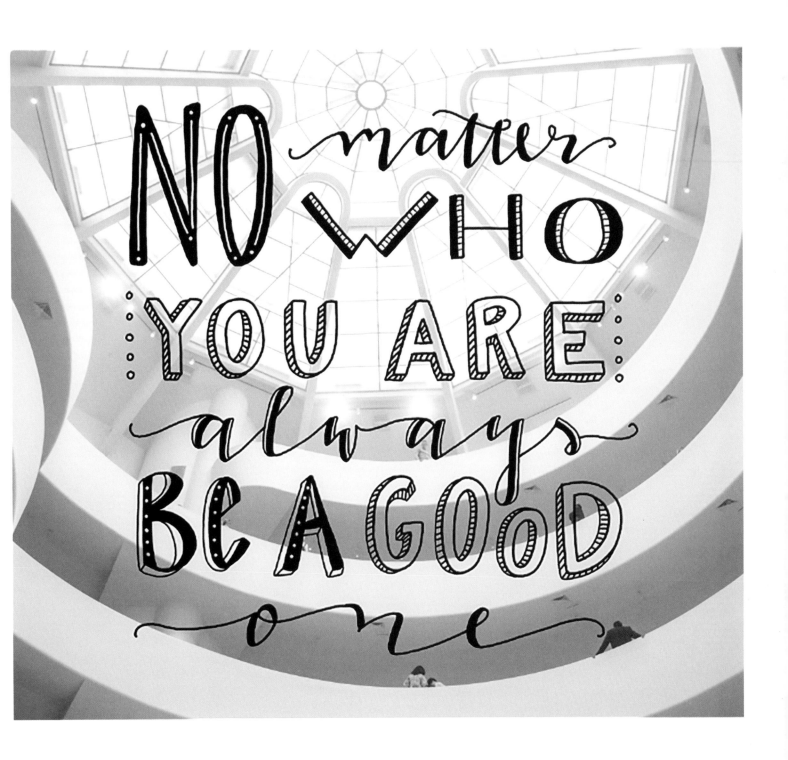

STEP FIFTEEN

Now you can publish your work online, print it, or use it for any other digitized project. Enjoy!

LETTERING WITH ALTERNATIVE MEDIA

One of the wonderful things about lettering is the vast array of materials that can be used to create beautiful words. Aside from traditional pens and pencils, you can make stunning lettered art with paints, markers, brush pens, and even found materials!

When you work with a new medium or tool for the first time, be sure to warm up and practice first to get used to its unique nuances and characteristics. For example, watercolor paint is a wonderful medium for rendering pretty lettering. It's also a water-based medium, which means you can't completely control the flow of the paint—and that's okay! With a little bit of practice first, you'll discover how the lovely qualities of watercolor paint can bring an airy, organic feel to your lettering.

If you try a new medium or technique and don't like it, move on and explore something else. We encourage you to try everything, because you never know what you may fall in love with! Learning any new medium can be challenging, but if you aren't having fun or are feeling frustrated, it's okay to move on to something that *is* fun. After you have mastered other mediums, you may even find yourself working your way back to try certain tools or techniques that you didn't like the first time around. That's the journey we all embark on as artists—ever changing, growing, and developing in our approach, skills, and artistry.

ADDITIONAL MEDIA

LOOKING FOR MORE LETTERING INSPIRATION? CHECK OUT THE BONUS CONTENT AVAILABLE ONLINE AT WWW.QUARTOKNOWS.COM/PAGE/LETTERING TO FIND TIPS AND STEP-BY-STEP EXERCISES FOR OTHER ALTERNATIVE MEDIA, SUCH AS EMBROIDERY, EMBOSSING POWDER, AND PAINT PENS!

Take a look at the fun and creative ways we've demonstrated lettering with alternative media in this section. Even if you don't have any experience working with these mediums, you'll find that you're able to create lovely lettering by starting simple and practicing your craft.

Brush Lettering

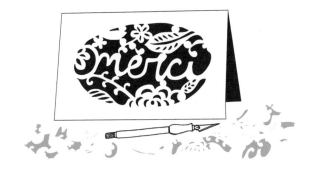

Paper Cutting

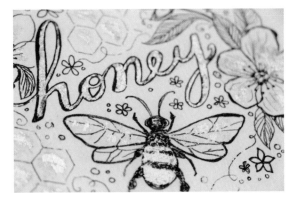

Watercolor & Gouache

Metallics

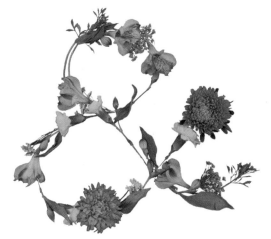

Found Materials

Brush lettering has been around for a long time. In modern practice, brush lettering is beloved for its unique and expressive qualities. Brush lettering can be used for elegant cursive or bold uppercase type.

Our two favorite pens to use are a soft-tip black brush pen and a refillable water brush pen. There are many different types of brush pens available, and we recommend trying as many as you want to find the right style for you!

Soft-tip Brush Pen

Refillable Water Brush Pen

Begin by practicing some different letterforms. Brush lettering can be very fluid, cursive, or even big and chunky. A big part of brush lettering is choosing the personality you want your letters to have. Here are a few examples:

Practice is the name of the game. After you get more confident with how the brush feels in your hand, you can start developing your own styles. A great way to do this is to make sample alphabets.

One of the most important tips to remember is to practice your strokes with a loose wrist. The art is all in the flow of your arm, which is exhibited in your lettering.

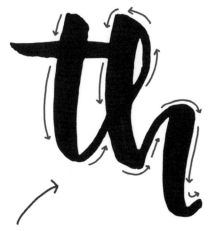

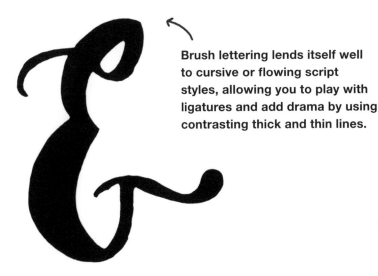

Brush lettering lends itself well to cursive or flowing script styles, allowing you to play with ligatures and add drama by using contrasting thick and thin lines.

It's especially important to understand the flow and strokes in these types of letterforms. Follow the lines marked with arrows here, which show the flow and order of the strokes.

PAPER-CUT HAND LETTERING

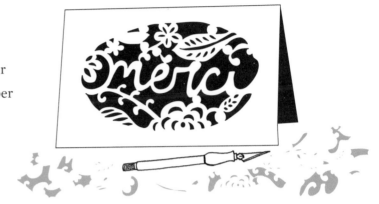

Paper cutting is a beautiful art form that can be traced back to the 6th century. Since then, cultures throughout the world have adapted it to create their own uniquely beautiful styles and applications. Paper cutting may be an ancient art form, but it is also a widely popular and versatile art movement today. Modern paper cutting has experienced resurgence among crafters and artisans, as well as corporate designers.

This pretty project demonstrates some of the basics of paper cutting. *Merci*, which means "Thank You" in French, is illustrated in a flowing script that is connected to the positive space. The negative space is cut away, along with surrounding floral elements.

MATERIALS

- Pencil
- Craft knife
- Cutting mat
- Ruler
- Card stock
- Scrap paper

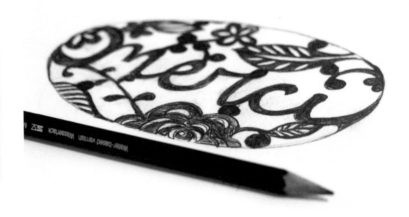

ARTIST'S TIP

START BY PRACTICING SIMPLE LINES AND CURVED CUTS WITH YOUR CRAFT KNIFE ON SCRAP PAPER. ONCE YOU'RE COMFORTABLE WITH THE KNIFE, DRAW SOME SIMPLE LETTERS TO PRACTICE CUTTING.

STEP ONE

Sketch your concept. Take the time to plan so you can prevent cutting mistakes. The whitespace of letters such as "e" will be cut out with the rest of your letter unless you open up the eye or connect your lettering to the positive space. This script font connects to the border design, which will enable me to keep the eye in my "e" and the tittle on my "i." I like to fill the positive space with pencil while sketching so I can visualize what the final art will look like. Then I copy over it with tracing paper so I have a clean, pencil-free outline.

STEP TWO

Trace or print your design onto the card stock of your choice.

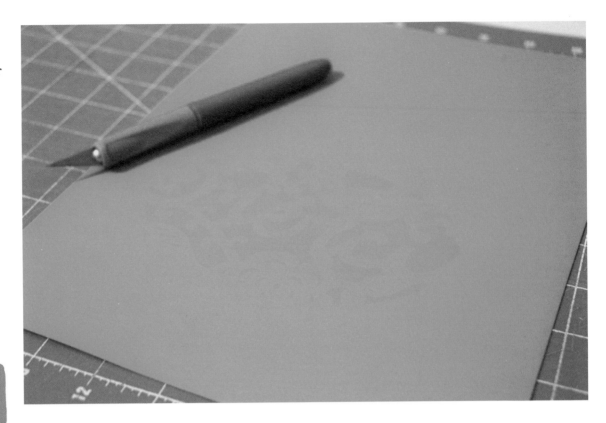

ARTIST'S TIP

DIGITIZE YOUR DESIGN SO YOU CAN EASILY MAKE MULTIPLE PRINTS AND HAVE THE OPTION TO PRINT ON DIFFERENT TYPES OF PAPER.

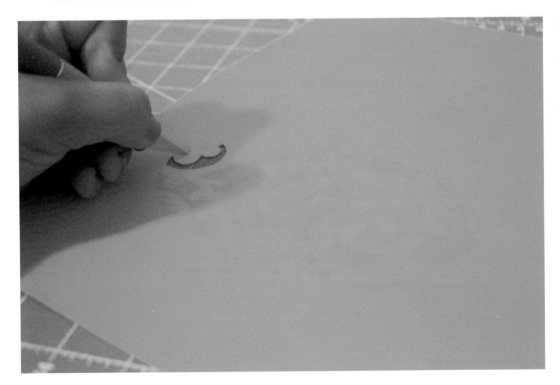

STEP THREE

Begin cutting one shape at a time, cutting just on the outer edge of your outline. Press firmly with the craft knife to cut completely through the paper. This can take some time, depending on how complex your design is, but just take it nice and slow.

STEP FOUR

Cut out all of the shapes, and go back to clean up finer details that need more finessing.

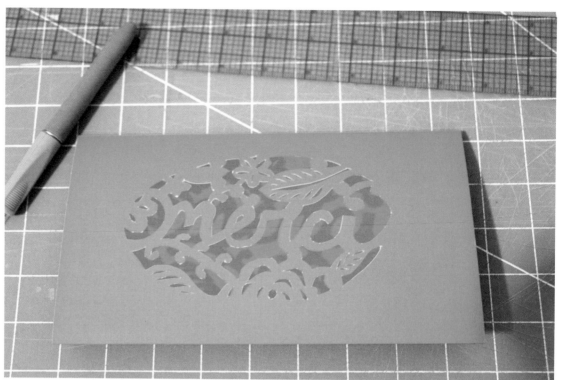

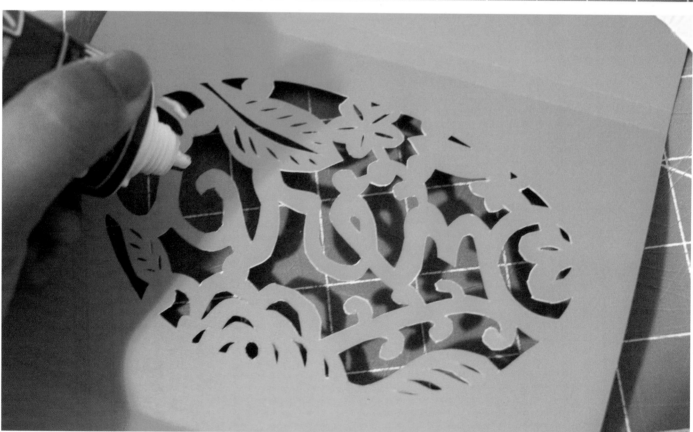

STEP FIVE

You can leave your paper-cut lettering as is, or you can add extra details to make the art really "pop." Try placing different textured and colored papers behind the artwork. When you find a combination you like, flip the lettered piece over and apply adhesive.

STEP SIX

Adhere the lettered artwork to the backing paper and let dry. I backed mine with a white pearl paper with beautiful swirling texture for added visual interest.

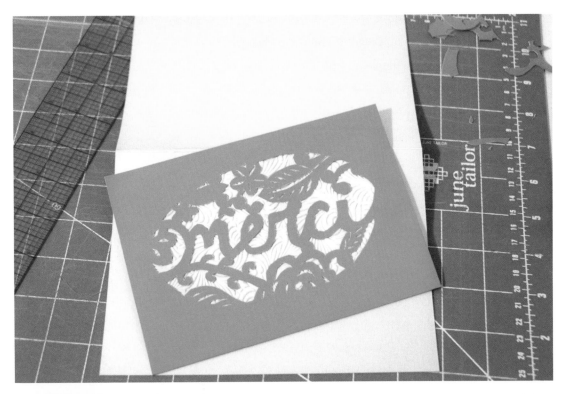

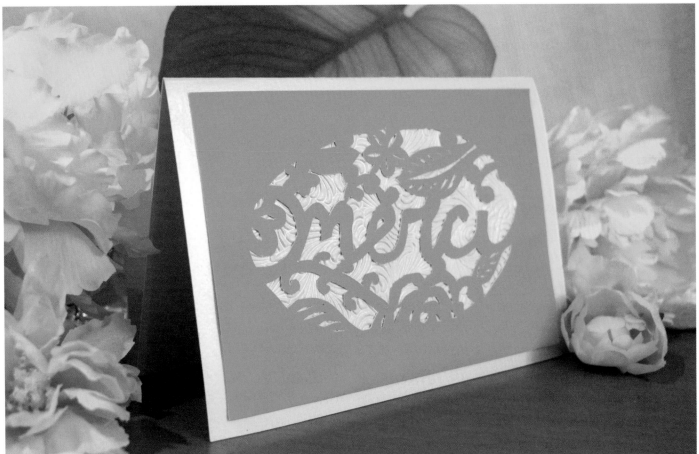

STEP SEVEN

Frame your artwork, or turn it into a pretty card like I did by gluing the finished art onto another folded piece of card stock.

WATERCOLOR & GOUACHE

Watercolor and gouache paints are wonderful mediums for adding color and a unique touch to your lettering. Watercolor paint is translucent, whereas gouache is opaque. This makes it fun to use gouache to paint over watercolor for a layered effect! This example uses watercolor paint. For these techniques you can use watercolor brushes or a water brush pen.

MATERIALS

- Watercolor & gouache paints
- Paintbrushes
- Watercolor paper (preferably 140-300lbs)
- Pencil
- Ruler
- Scissors

STEP ONE

To get started, measure and trace the outline for the size of your artwork. Mine is 8" x 10". Then trace or sketch the lettering.

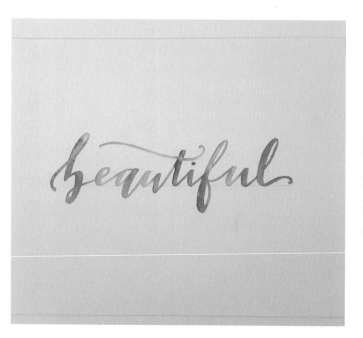

STEP TWO

Now you're ready to start painting! The fun thing about lettering with watercolors is the degree of variance you can achieve, giving your work wonderful texture.

STEP THREE

You can let the lettering shine solo or add decoration and design. I painted a simple abstract design.

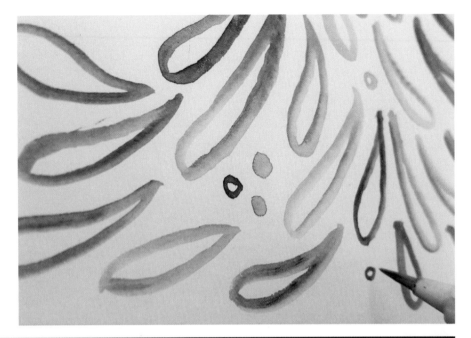

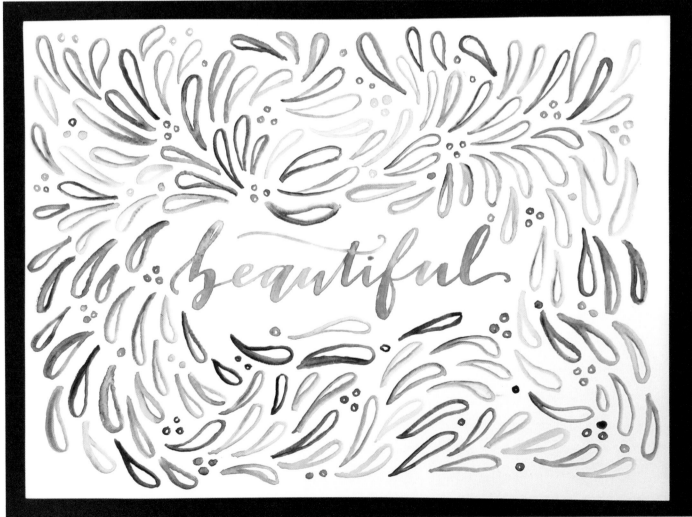

METALLICS

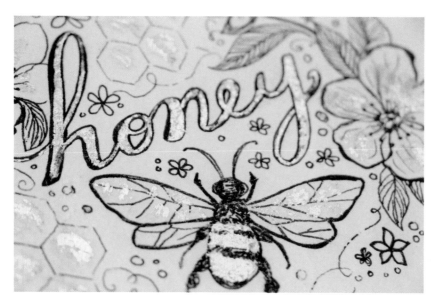

Metallic accents can be found everywhere, from home décor to paper products. These eye-catching finishes reflect light to make your lettering projects "pop." There are a variety of ways to achieve a metallic finish, including foil. If you're searching for ways to add extra sparkle to your lettering, try one of these techniques!

FOIL BY HAND

Foil artwork and design elements are a widely popular trend. This technique shows you an easy and affordable way to add foiled details to your lettered projects. Working with foil can seem intimidating, but this method is very simple and fun. This technique works best for designs that don't need precise, straight lines—it's perfect for adding little bits of sweetness and shine to organic hand-lettered designs.

MATERIALS

- Pencil
- Permanent archival ink pen
- Glue that dries tacky
- Fine-tipped paintbrush
- Foil sheets
- Bone folder

STEP ONE

Sketch your design, and then fill in with ink.

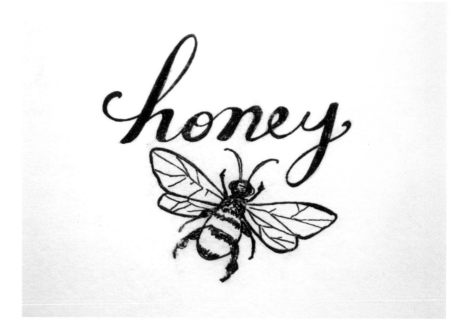

STEP TWO

Use a fine-tipped paintbrush to apply glue on any of the details you want to foil. Be sure to evenly cover the entire area you wish to foil. Let the glue dry until tacky to the touch.

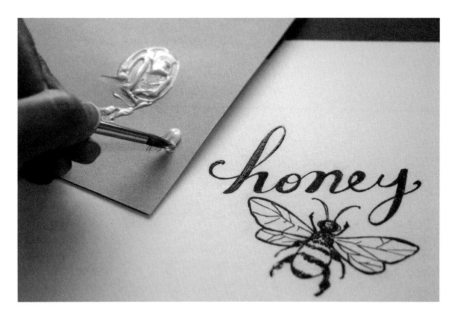

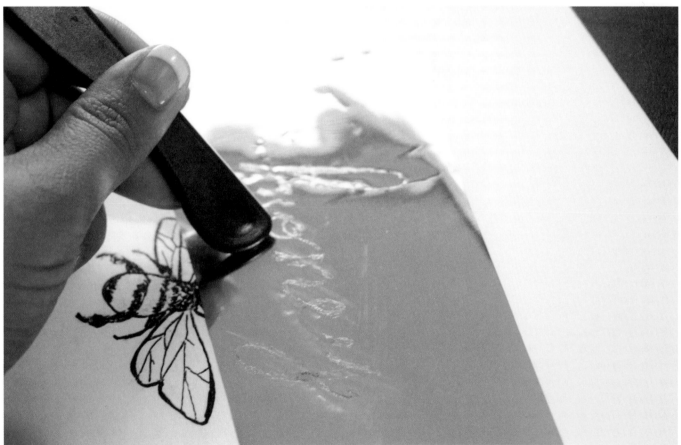

STEP THREE

Apply a foil sheet over the glue and press down firmly and evenly. Then use a bone folder tool to rub the surface. You will see the foil impression as it separates from the plastic and adheres to your paper.

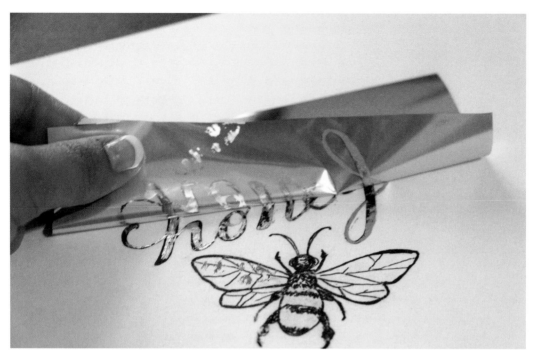

STEP FOUR

Carefully pull away the foil sheet from your artwork.

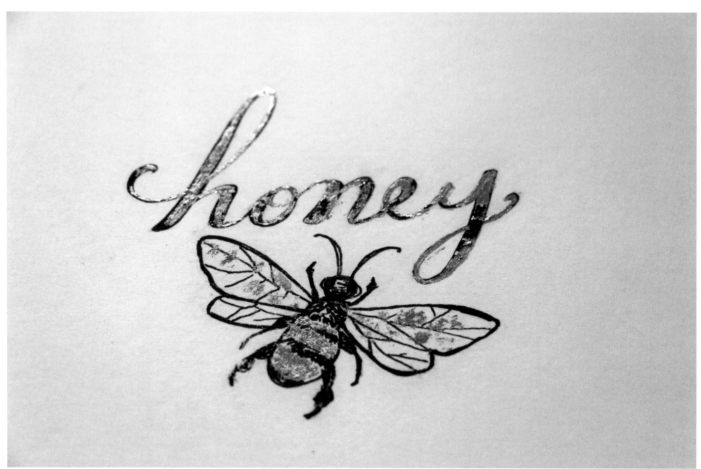

STEP FIVE

Repeat steps two through four to add additional foil details.

STEP SIX

If you like, add in additional ink and foil details around the lettering.

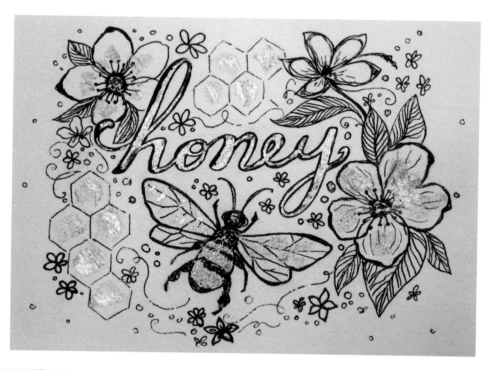

STEP SEVEN

Frame or hang your finished hand-foiled lettering. This is a great way to add a metallic touch to just about any project. You could add a hint of foil to a table sign, card, handmade product labels, or even business cards. There are so many fun applications for this technique!

LAMINATED FOIL

Do you want to know the secret to creating fancy foiled artwork that looks and feels high-end? This method of foil application creates crisp lines, smooth graphics, and a beautiful metallic finish that looks like it was printed by the pros. This technique requires a few extra steps and materials, but the end product is well worth the extra effort. Create your own upscale foil lettering for invitations, printed materials, wall décor, and just about any paper product you can imagine.

MATERIALS

- Photo-editing software of your choice
- Laser printer (Alternatively, have your designs professionally printed on a laser printer.)
- Thermal laminator (Note: You don't need an expensive laminator, just one that gets really hot and applies firm pressure. You may also choose to invest in a foil applicator machine.)
- Heat-reactive foil sheets
- Scissors
- 8.5" x 11" matte paper
- 8.5" x 11" printer paper

STEP ONE

Design and set up your artwork. I created my design and hand lettering digitally with a Wacom® tablet. You can do the same, or you could type a phrase in your favorite typographic style of lettering or convert a hand-drawn design to digital artwork. (See pages 64-71 for a tutorial.)

STEP TWO

Set up your design to print with solid black. Foil binds to toner, so the print needs to be one hundred percent black to bind correctly.

STEP THREE

If you own a laser printer, you may print your design from home on a piece of medium-weight 8.5" x 11" matte paper. I went to a local printer and asked them to print my design with a laser printer and pure black toner.

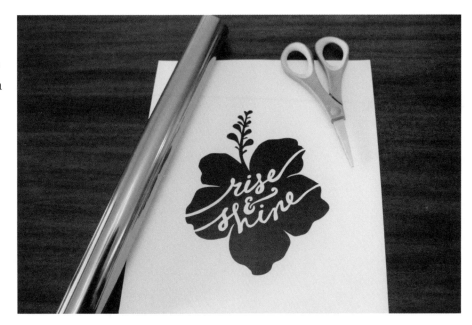

ARTIST'S TIP

WHY DOES ARTWORK NEED TO BE PRINTED WITH A LASER PRINTER? LASER PRINTERS USE TONER. FOIL BINDS TO THE TONER WHEN HEAT AND PRESSURE ARE APPLIED. UNFORTUNATELY, INK-JET PRINTING WON'T WORK FOR THIS FUN TECHNIQUE.

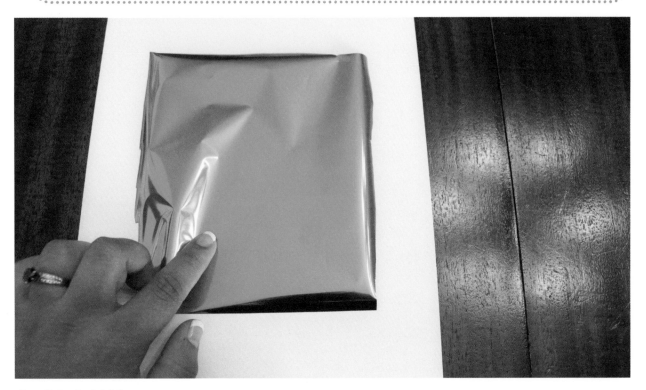

STEP FOUR

Turn on your thermal laminator to the hottest setting available, and let it get nice and hot. While you're waiting for it to warm up, lay a foil sheet over your design and cut the foil to size; then cover your design with the foil sheet.

STEP FIVE

Place a regular piece of printer paper on top of the foil to hold it in place.

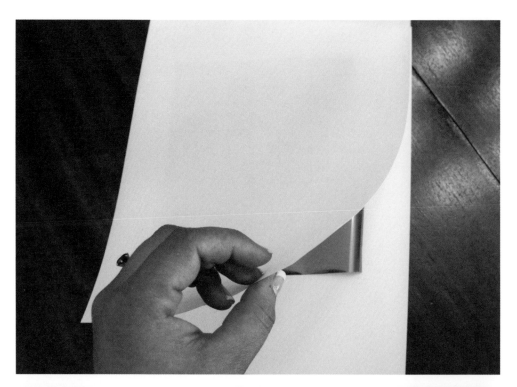

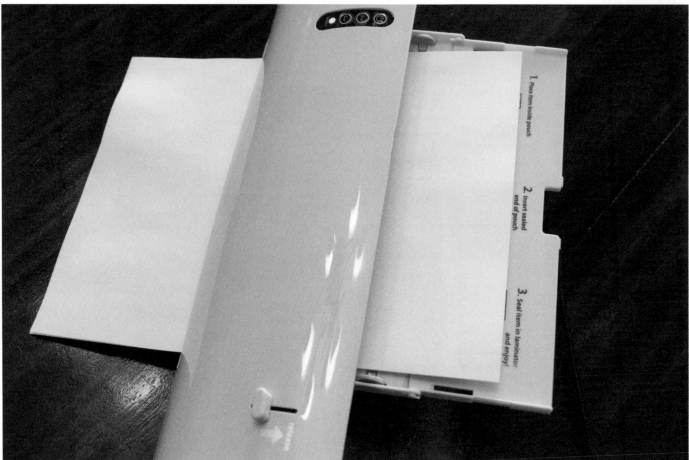

STEP SIX

Feed your design, foil, and cover sheet through the laminator.

STEP SEVEN

Let cool slightly; then gently remove the foil from your artwork. Frame, hang, and enjoy your custom foil creation!

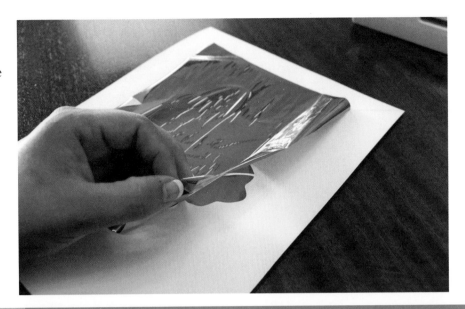

Trouble-
SHOOTING

If the foil doesn't come out evenly and you find any black spots, there are a few adjustments you might try.

- THE LAMINATOR MIGHT NOT BE HOT ENOUGH. LET IT WARM UP FOR AT LEAST 15 MINUTES. IF YOU HAVE DIFFERENT HEAT SETTINGS ON YOUR LAMINATOR, MAKE SURE TO SET IT TO THE HIGHEST SETTING.
- MAKE SURE THAT YOUR FOIL IS LAYING FLAT AND WRINKLE-FREE OVER YOUR ARTWORK BEFORE PLACING THE COVER SHEET OVER IT AND LAMINATING.
- YOUR PRINTER MIGHT BE RUNNING LOW ON TONER OR YOU MAY NOT HAVE PRINTED WITH PURE BLACK TONER. TRY PRINTING THE ARTWORK AGAIN.

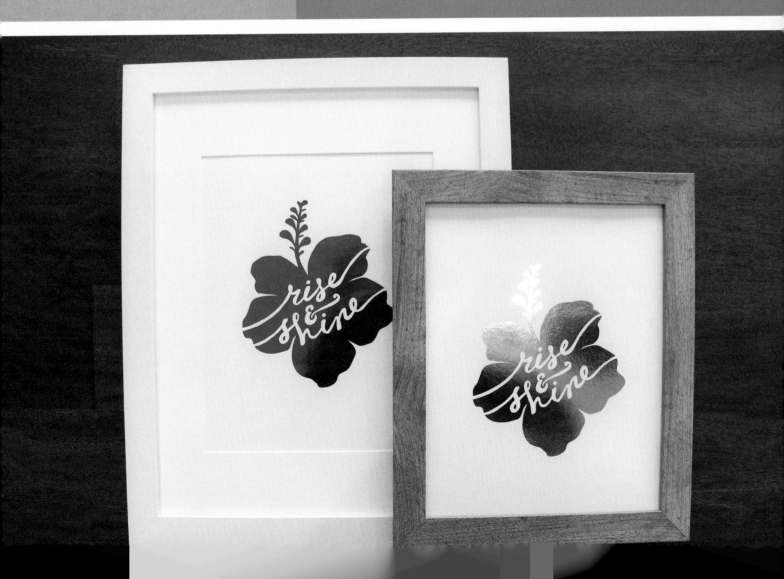

FOUND MATERIALS

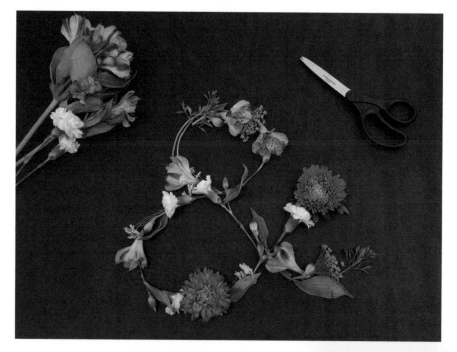

There are myriad creative and beautiful ways to create unique lettered artwork with a variety of unusual materials. From food to flowers to found objects, anything is fair game! Try these easy methods for lettering with found materials, and then experiment with other materials to see what you can come up with!

LIVE FLORALS

It's easy to create lettering using flowers that you can pick up from your local florist. Follow along to create this pretty ampersand. Then try lettering your initials or your favorite number.

MATERIALS

- Solid-colored background (such as black foam core board)
- Live flowers
- Scissors or shears

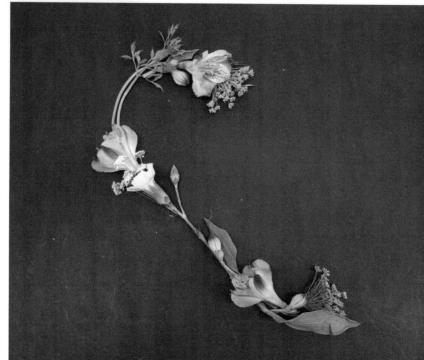

STEP ONE

Begin to arrange small bits of flowers and plants in the shape of your letter, placing flowers and leaves over the cut ends of stems to create a seamless look.

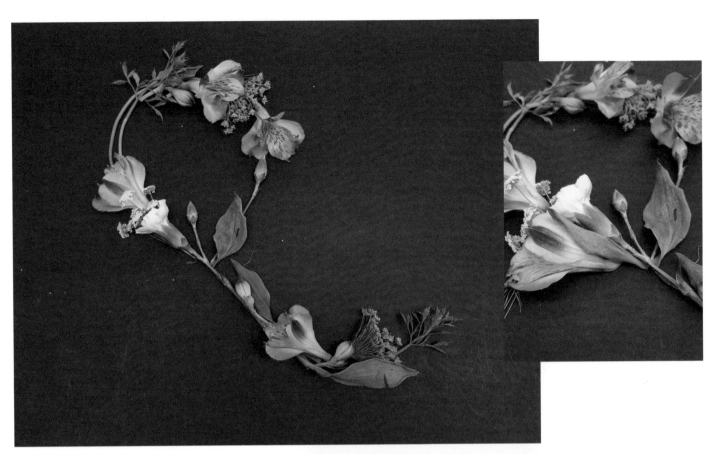

STEP TWO

Continue building the letterform, tucking stems and flower ends underneath leaves to hide the transition from one piece to another. Tucking the ends in under the arrangement makes them appear as if they naturally grow there. Use bunches of short-cut plants to create the curves.

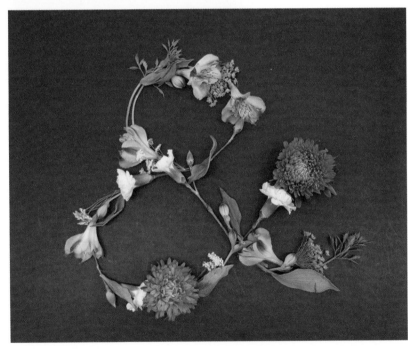

STEP THREE

Finish your arrangement with some bright accent flowers, and clean up any bits and pieces around the artwork. This may be a short-lived art form, but if you photograph your work you can preserve its beauty in prints for years to come!

FOOD

Now that you've worked with flowers, it's time to take it up a notch to food! In this demonstration we'll work with spices.

MATERIALS

- Dark-colored background (such as black foam core board)
- Spices
- Plastic sandwich bags
- Scissors
- Craft knife

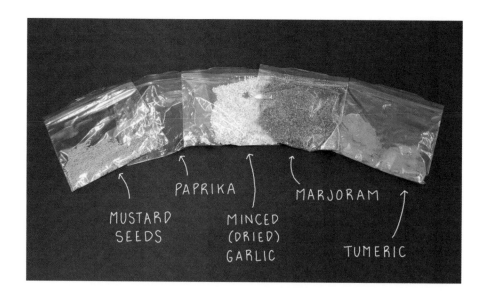

STEP ONE

Start with your spices in sandwich bags. I chose brightly colored spices: mustard seeds, paprika, minced (dried) garlic, marjoram, and turmeric.

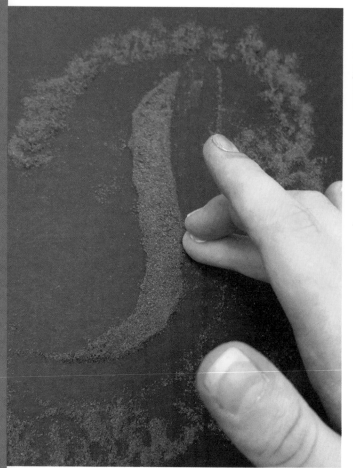

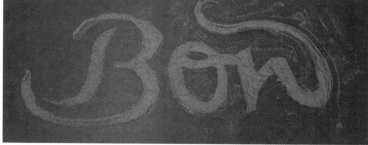

STEP TWO

Begin by cutting the bottom corners of the plastic bags, which will allow you to dispense the spices in a controlled manner. Dispense the first spice in the general outline of the letters, and use your fingers to compress and shape the spice into the shape of your letters. Be prepared for your fingers to turn the same color as the spices!

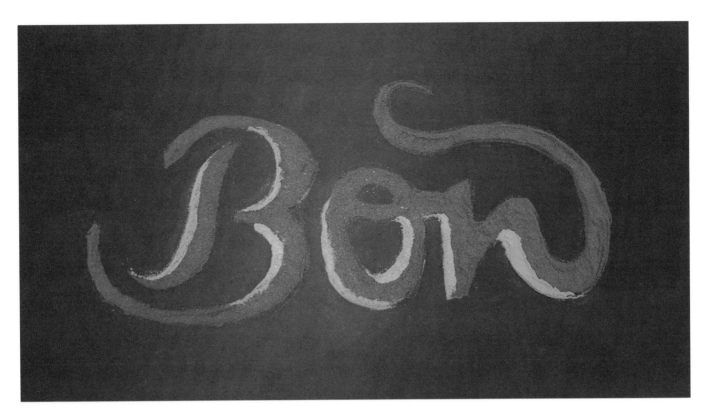

STEP THREE

Use the tip of your finger or a cotton swab to clean up any excess spice. Then add dimension with another spice in a contrasting color. I used bright yellow turmeric.

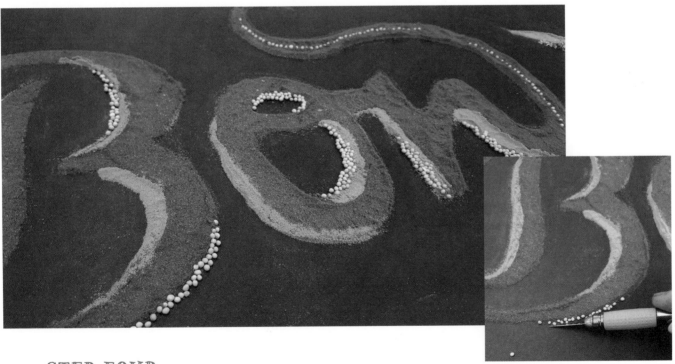

STEP FOUR

Add detail and texture with mustard seeds. You can drop them carefully onto the spices or use a craft knife to carefully place them along the edges of the letters.

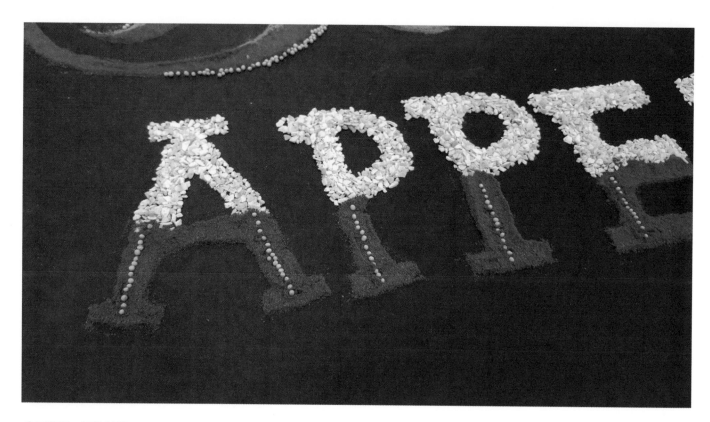

STEP FIVE

Finish the rest of the phrase in similar manner, or explore using other spices to add more texture and visual interest. Here I used minced garlic with paprika for bold contrast to form the rest of my letters. I also added mustard seeds as an embellishment.

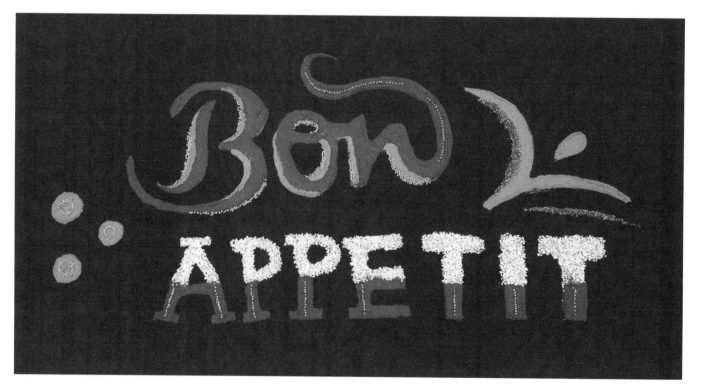

STEP SIX

Finish by adding decorative elements. Then grab your camera and shoot some photos! This kind of project is perfect for creating your own custom recipe cards or a unique cover for a family cookbook.

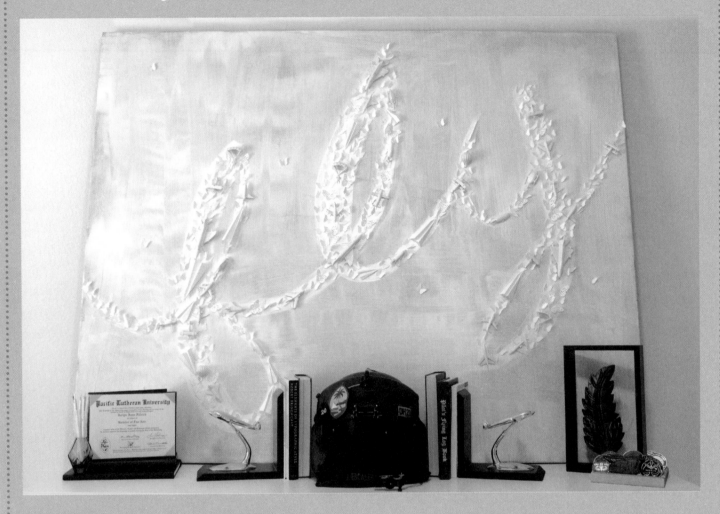

Create unique, contemporary lettered artwork for any space with found objects. This monochromatic art piece uses subtle changes in color, depth, texture, and shadow to form the letters. You can collect any type of objects you like. I chose a mixture of objects that contrasted fragility with sturdiness, feminine with masculine, childlike with sophisticated, and art with aviation. I was inspired by childhood dreams and humanity's shared intrinsic aspiration to reach for the sky.

FIND THE STEP-BY-STEP TUTORIAL FOR THIS PROJECT ONLINE AT WWW.QUARTOKNOWS.COM/PAGE/LETTERING!

LETTERING SURFACES & PROJECTS

Once you have started your journey into lettering and typography there is no limit to the ways you can use this innovative and uniquely personal art form to create myriad art pieces, gifts, home décor items, and paper goods. From custom logos and stationery to dramatic wall murals and DIY fonts, you can take your lettering skills just about anywhere you wish!

In this section of the book, you'll discover a series of easily customizable DIY projects that invite you to finesse your skills and explore lettering in new ways. As you work through the projects, remember that you can change *anything* you wish to make a project uniquely yours. Use our examples as a guide, and take all the artistic license you need to create lettered work that showcases your personality and style.

With the right tools, you can letter on almost any surface. Glass, wood, ceramics, walls... not to mention paper and canvas. The examples in this section are just a small glimpse of the possibilities. So take all of the knowledge, skills, and inspiration you can glean from this book and embrace your own artistic journey as you revel in the joy of lettering.

BONUS PROJECTS

DON'T FORGET TO CHECK OUT THE BONUS CONTENT AVAILABLE ONLINE AT WWW.QUARTOKNOWS.COM/PAGE/LETTERING FOR MORE LETTERING TIPS, TECHNIQUES, AND STEP-BY-STEP TUTORIALS!

On the following pages you'll find several ideas and step-by-step tutorials for some of the ways you can take the skills you've learned to the next level by creating a range of customized, hand-lettered projects.

From gift wrap and stationery...

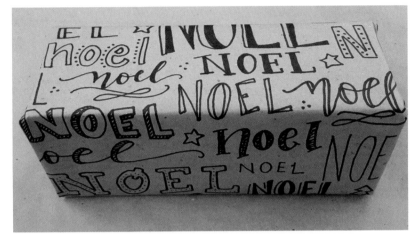

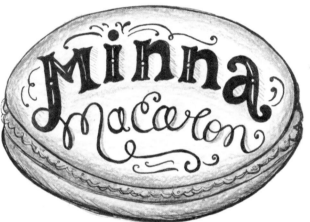

To professional-looking logos...

DIY fonts...

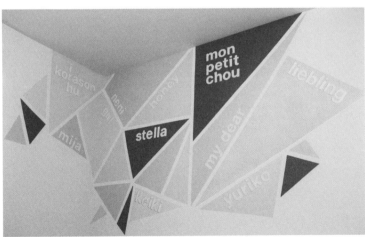

...and even home décor—plus more!

WRAPPING PAPER

We all use wrapping paper year round for birthdays, parties, and holidays—creating your own custom, hand-lettered wrapping paper is sure to make a good impression on your friends and family! I chose to make holiday wrapping paper using the word "Noel" in many contrasting lettering styles.

MATERIALS

- A roll of paper in your preferred size and type (I like plain kraft paper or black kraft paper)
- Paint pens or permanent markers (not oil-based)

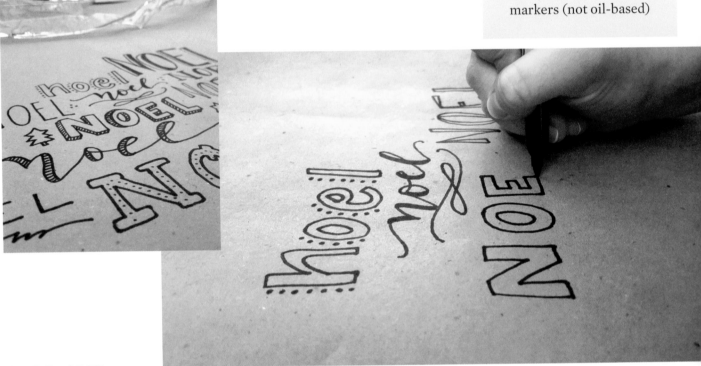

STEP ONE

Unroll and tape or weigh down your paper on a hard surface, such as a table or hardwood or tile floor. You can do some sketches before getting started if you prefer. Begin filling the paper with lettering. Adding texture with 3-D letters, hash marks, and a combination of cursive, block, serif, and sans serif letters greatly enhances the depth and impact of your lettering. You can also add small decorative touches, such as stars and Christmas trees.

ARTIST'S TIP

IF YOU USE A PAINT PEN, MAKE SURE YOU FOLLOW THE MANUFACTURER'S INSTRUCTIONS IN ORDER TO PREP YOUR PEN. MOST PAINT PENS REQUIRE A COMBINATION OF SHAKING AND PRESSING DOWN THE TIP UNTIL IT IS READY TO USE.

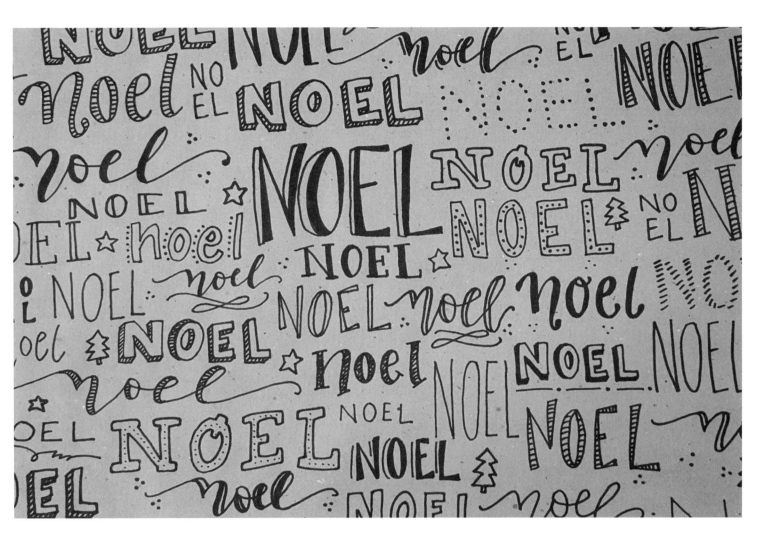

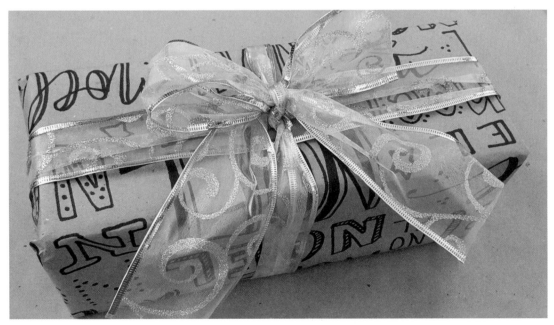

STEP TWO

Fill as much of the paper as you can or want to, and be sure to let the ink dry before rolling up for future use or wrapping gifts.

GIFT TAGS

Now that you've designed custom wrapping paper, finish your gifts with these easy, hand-lettered, personalized gift tags.

MATERIALS

- Tags (wood or chalkboard)
- Paint pens (not oil-based)
- Sealant spray (optional)

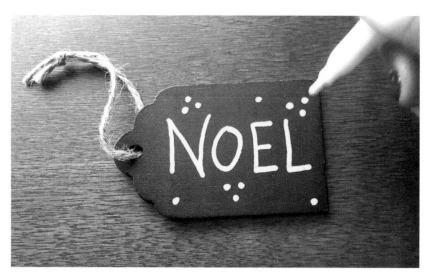

STEP ONE

Prep your tags by wiping them with a damp cloth, and allow them to fully dry before lettering. Be sure to follow the manufacturer's instructions for prepping your paint pen. If you like, plan or sketch out your tag on a piece of scrap paper before marking the tag. When using a paint pen, it's important to letter quickly before the paint dries. Start with the basic lines of your letters first.

ARTIST'S TIP

YOU CAN ALSO CREATE PRETTY CUSTOMIZED GIFT TAGS USING JUST CARD STOCK AND YOUR FAVORITE MARKERS OR PENS! SIMPLY CUT OR PUNCH OUT THE SHAPE OF THE TAG, ADD YOUR LETTERING, AND FINISH WITH RIBBON OR TWINE.

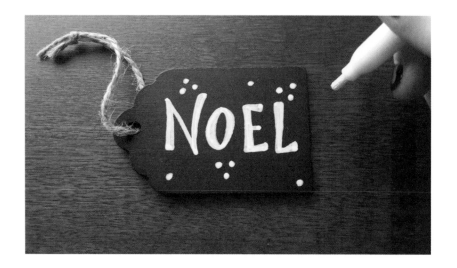

STEP TWO

Next thicken and define your letters. You can also add decorative designs around your lettering.

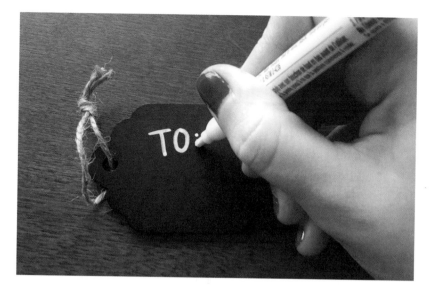

STEP THREE

Allow the front of the tags to dry completely. Once dry, you can use the back of the tags to add your gift personalization.

STEP FOUR

Allow the tags to dry completely. Once they are dry, you can add a coat of sealant spray if you wish, and they are ready to be attached to a present.

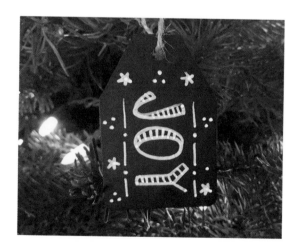

Bonus: These tags also double as cute Christmas tree ornaments!

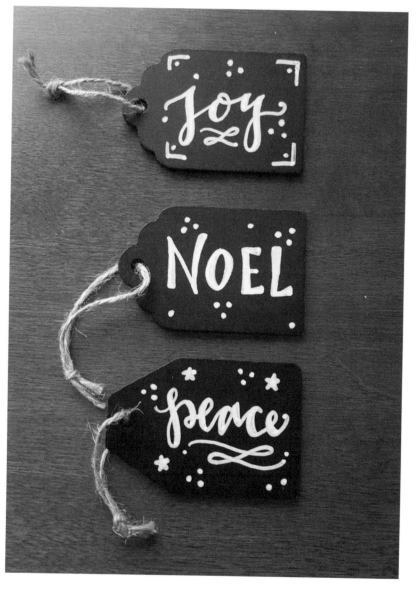

ARTFUL ENVELOPES

MATERIALS

- Envelopes
- Pencil
- Ruler
- Opaque pigment pens & metallic paint pens

One of my favorite surprises is opening the mailbox to find a handwritten letter or beautiful custom invitation. Equally enjoyable is writing a thoughtful card or letter and sending it in the mail. Modern technology is great for keeping us connected to far-away loved ones, but it is especially meaningful to give or receive old-fashioned letters. Whether you're sending a letter, invitations, a resume, or a care package, adding artful custom lettering will truly make your mail stand out. The envelope is the first thing your recipient will see, so why not make a great first impression! Just be sure to review your local post office recommendations to ensure that your lettering and placement adheres to postal guidelines.

ELEGANT ENVELOPES

These elegant hand-lettered envelopes might be the perfect way to address holiday cards or add the finishing touch to wedding invitations. Try using a white opaque pigment pen on a dark-colored or metallic envelope for a dramatic and unexpected touch.

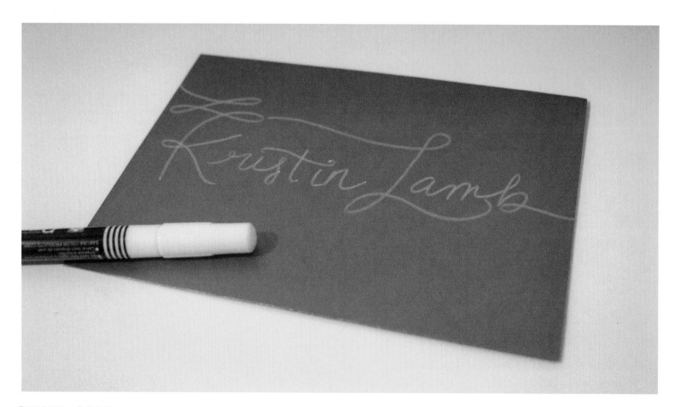

STEP ONE

Begin by quickly scripting the outline of your recipient's name across the center of the envelope. Note that some specialty papers, such as these metallic gold envelopes, won't hide pencil indentations or eraser marks well, so you may want to letter directly on the envelope like I did.

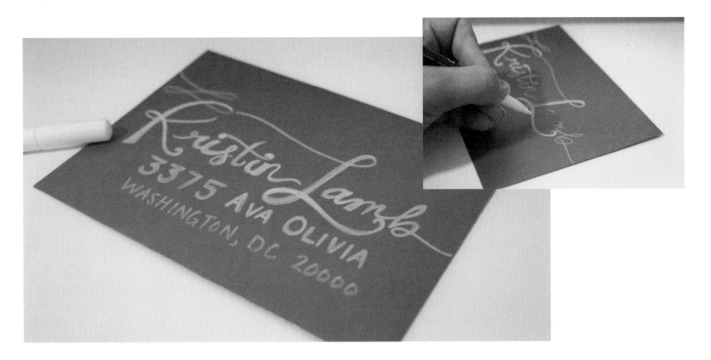

STEP TWO

Go over your outlines and mimic calligraphy strokes by making the down strokes thick and the up strokes thin. Then add the recipient's address. You can still use a pretty and stylish font—just make sure it is easy for the postmaster to read.

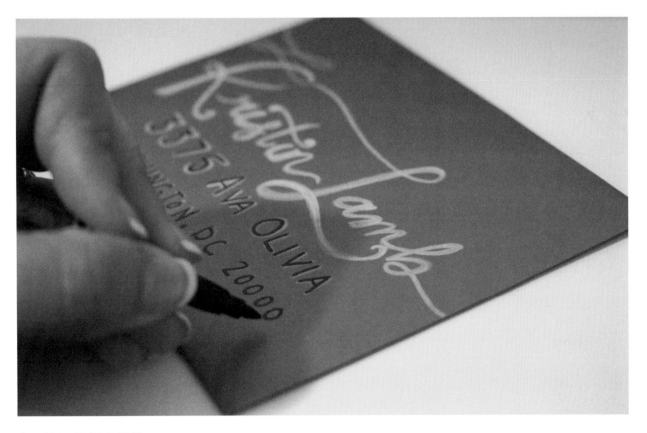

STEP THREE

This step is optional, but I like to trace over the recipient's address with a black pen to make it stand out on the gold background and increase its legibility.

OVERSIZED ARTFUL ENVELOPE

These playful, oversized custom envelopes feel extra special in hand. They are a terrific way to send 8.5" x 11" paper documents if you want to avoid folds. The beautiful pops of color, unexpected lettering placement, and accompanying artwork make this envelope feel like a standalone piece of art! This is a creative way to send a loved one a special letter or piece of artwork. If you work in a creative field, these envelopes are also a unique way to send portfolio samples, artwork, or various materials to prospective clients.

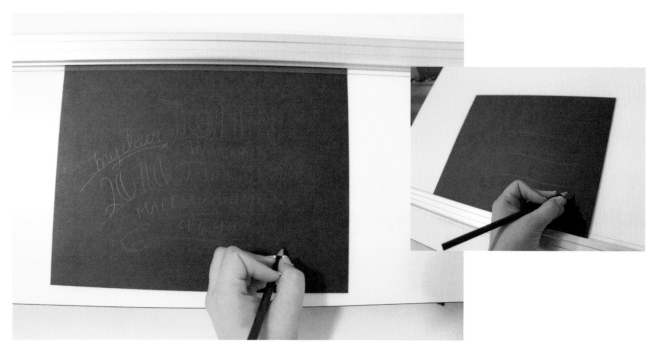

STEP ONE

Lightly pencil in guidelines for your lettering. Then draft your lettering. Lightly sketch with pencil so you are able to adjust spacing accordingly.

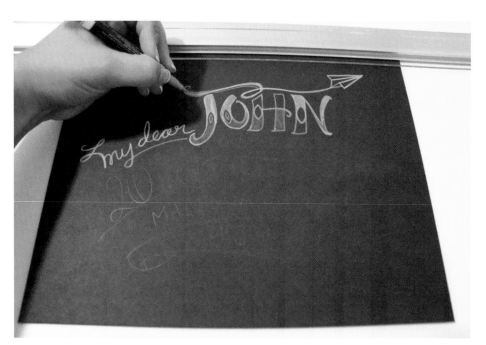

STEP TWO

Outline and add color and creative details to the recipient's name.

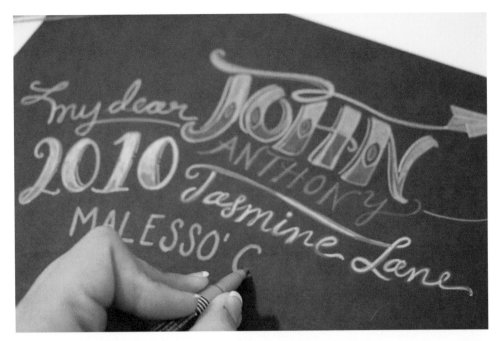

STEP THREE

Use a pen to outline the address. If you're left-handed like me, work one line at a time and then go back over the line to add color and detail before moving to the next line to prevent smudges!

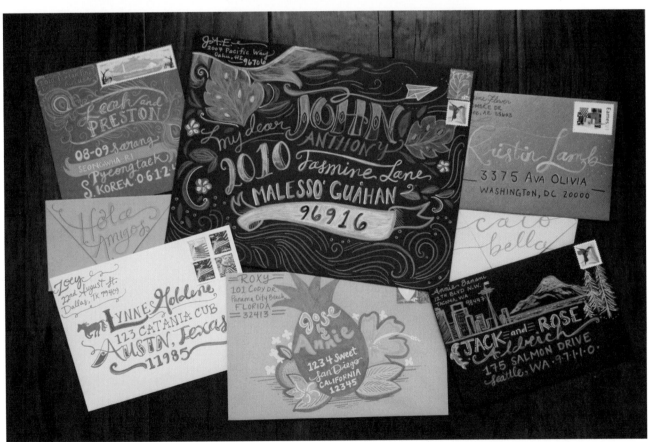

STEP FOUR

After you finish hand lettering the address, add in playful details and flourishes. Let your creative juices flow, take some chances, and have fun. Just think how flattered your recipient will be when they are surprised with one of your custom lettered envelopes in the mail!

HAND-LETTERED LOGO

MATERIALS

- Artist pencils
- Waterproof, artist-quality, archival ink pens in various sizes (I usually use .50mm and .20mm)
- Sketch pad
- Graph paper
- Tracing paper
- Camera

There are many factors to consider when developing a logo. Deliberate choices with wording, colors, imagery, and typography all play into the success of a brand. Hand lettering a logo is a significant way to give branding a distinguished, one-of-a-kind touch. Give it a try, and design your own logo for your creative company, personal brand, or blog!

STEP ONE

Before you begin, write down a few words that describe your brand. Experiment with hand lettering those words in a style reflective of their meaning. The words shown here are those I came up with to reflect the branding for a macaron bakery.

Conceptualizing and sketching will help you determine what types of lettering to use. I want to create a lettered logo that truly feels handmade. My logo needs to have an organic quality that doesn't seem too rigid, corporate, or generic. For this reason, I selected a sweet, swirling script and a stylized serif that aren't precisely symmetrical. These lettering choices will help enhance the mood words I have chosen to reflect my branding.

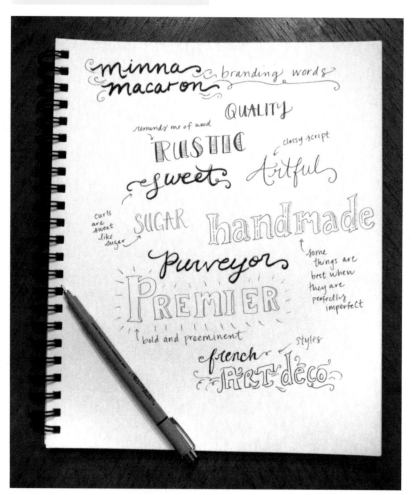

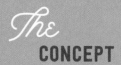

The CONCEPT

STEP TWO

After you have considered your branding, start sketching. I start my sketches with pencils on graph paper. Remember that this process isn't about perfection—it's about getting your ideas out on paper. You can do as few or as many sketches as you need.

ARTIST'S TIP

USE TRACING PAPER TO TRANSFER YOUR FINAL SKETCH. TRACING PAPER ALLOWS YOU TO FINESSE YOUR LETTERING LINES AND SEE WHAT CHANGES YOU WANT TO MAKE ON THE FINAL LOGO. IT ALSO ALLOWS YOU TO MAKE QUICK CHANGES WITHOUT REDRAWING YOUR LETTERING FROM SCRATCH EVERY TIME. USING TRACING PAPER ALSO KEEPS YOUR FINAL ARTWORK FREE FROM PENCIL AND ERASER MARKS.

STEP THREE

Once you have picked your logo design, it's time to perfect your sketch. I prefer to use pencils and a fresh piece of graph paper for this part of the process. Lightly sketch the logo with pencil, and then go back over it to finesse the details. This is still just a sketch, so you don't need to clean up every line. The goal is to have a good idea of what your final hand-lettered logo will look like.

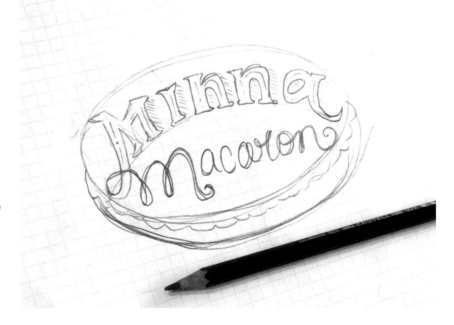

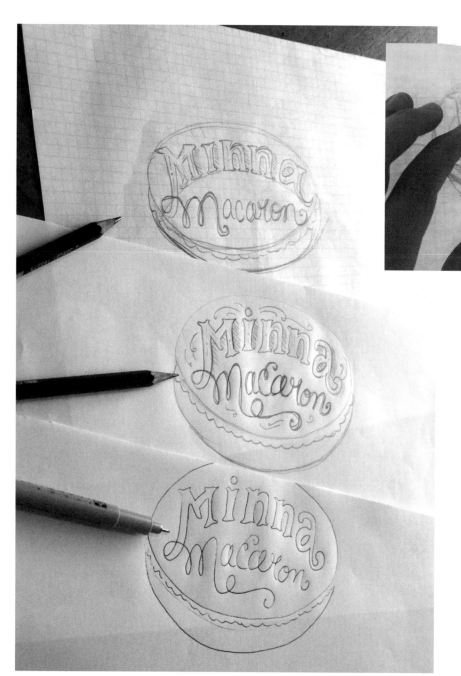

STEP FOUR

It's time to transfer your logo. This is a fun process that can have as few or many steps as you feel you need. I used a two-step process for this logo. On my first sheet of tracing paper I used pencil again, keeping my lines as clean as possible and adding in details I knew I wanted on my final piece. From there, I used a second piece of tracing paper to ink the logo outline with a fine-point archival ink pen.

STEP FIVE

Once you have finished the transfer process and are happy with the outline for the final logo, use various sizes of archival ink pens to go back over the outline and add final details to the logo.

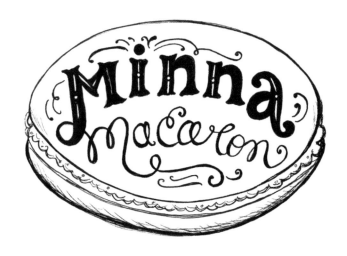

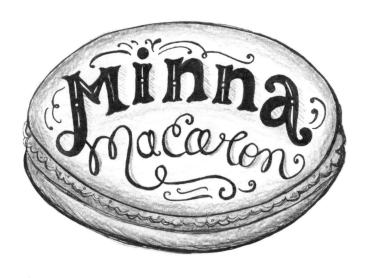

STEP SIX

I always create hand-lettered logos in black and white first, even if I know what colors the branding will incorporate. Starting with a black-and-white logo allows me to focus on the basic form. I usually transfer the black-and-white logo into my computer and convert it to a vector graphic before adding color. However, after you have photographed or scanned your black-and-white logo for safekeeping, it's fun to play with colors and textures. You can experiment with different mediums, such as pens, colored pencils, or watercolors to give you an idea of how you would like your final digital logo to look.

ARTIST'S TIP

AFTER YOU FINISH PERFECTING YOUR FINAL PIECE, TAKE SOME TIME TO PHOTOGRAPH OR SCAN YOUR HAND-LETTERED LOGO. IDEALLY, YOU SHOULD USE A DIGITAL CAMERA THAT TAKES GOOD-QUALITY, HIGH-RESOLUTION PHOTOGRAPHS. SEE PAGES 64-71 FOR TIPS.

Turn the page to the next tutorial to learn how to convert a hand-lettered logo into a professional vector logo like this!

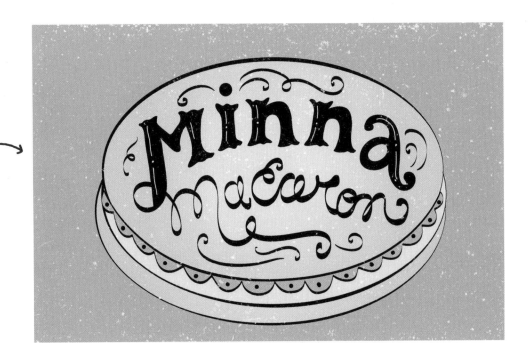

SKETCH-TO-VECTOR LOGO

MATERIALS

- Camera or scanner
- Good light source
- Image-editing software (such as Adobe® Photoshop®)
- Vector-based software (such as Adobe® Illustrator®)

You have sketched and perfected your beautiful hand-lettered logo. Perhaps you would like to try converting that logo into a vector graphic. Once you convert your logo to a vector graphic you can have it printed on just about anything—and in any shape, size, or color you like! The process takes practice and patience, but with time you will achieve some remarkable results. Converting your logo to a vector allows you to truly give your work a custom, professional edge.

What is a vector graphic, and why would you want your logo to be a vector file format? Vector graphics are made with anchor points and paths. These paths can be straight lines or curves. The anchor points direct where the path goes. To think of this in a simplified way, imagine a connect-the-dots coloring page, in which lines are drawn from dot to dot. Once all the lines are connected, the dots and lines create an image.

Vector paths can be used to create simple shapes or complex graphics. Professional digital typographers use these points and paths to create the lines, angles, and curves that make up their type forms. The benefit of vector-based graphics is that, since they are not comprised of pixels, they can be enlarged to any size and remain clear and crisp. This is possible because the paths and points are created by a mathematical formula that scales accurately to any size. No matter how large you make your vector logo, it remain sharp and clear.

Below is an example of pixel art vs. vector art.

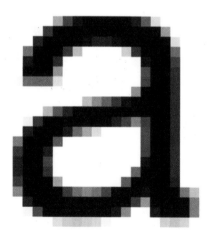 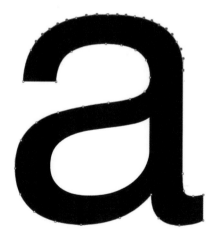

PIXEL ART If you enlarge pixel art enough, you can see that it is made up of many dots, which are called pixels. The larger you scale the image, the more these dots show and distort the image, creating pixilation.

VECTOR ART Vector art is made up of paths and points that determine the line, curve, and shape of the graphic. No matter how large the image is scaled, it retains visual integrity.

There are a few ways to create a vector logo from your sketches. I will lead you through this process starting with the "Image Trace" tool, which automatically converts your image to a vector. After we have explored this process and some of the "Image Trace" features, I will briefly show you how to manually draw a portion of the logo and finesse your logo using the pen tool.

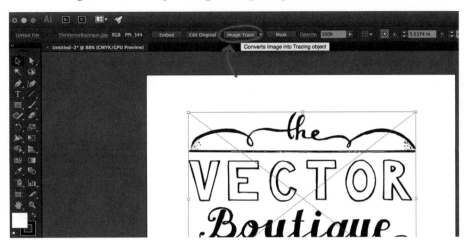

STEP ONE

Photograph or scan your hand-lettered logo, and edit it in Adobe Photoshop or similar photo-editing software of your choice. (Refer to pages 64-71 for instructions on how to prep your photograph and separate the lettering from the background.) Save the edited file as a high-resolution JPG file. Then open Adobe Illustrator and place the file on a new document. With the image selected, find the "Image Trace" button in the properties bar along the top of the screen. Click the button, and your image will be converted into a preview of what the vector will look like.

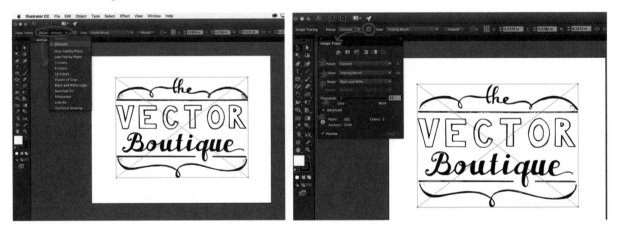

STEP TWO

There are many options that allow you to finesse the way Illustrator traces your vector. I recommend previewing different options on the "Trace Presets" (see above left) and opening up the "Image Trace Panel" (see above right). If you aren't satisfied with how the image has been traced, try using different presets and adjusting the threshold. The threshold controls the value for determining what will be traced. Pixels lighter than the threshold are converted to white, so adjusting the threshold will adjust how the edges of the image will appear.

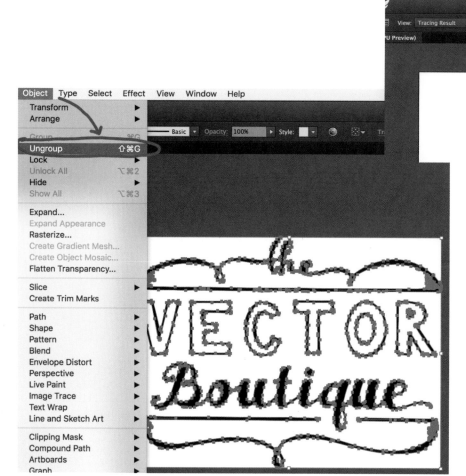

STEP THREE

After you have set the presets, threshold, and tracing results the way you like, select "Expand," which is located on the properties bar by the "Image Trace" button (see inset). Expanding the art converts the preview to a group of vector paths. From here the vector can be edited further. Start by ungrouping your vector logo by selecting "Object" from the menu bar, and "Ungroup" from the drop-down menu.

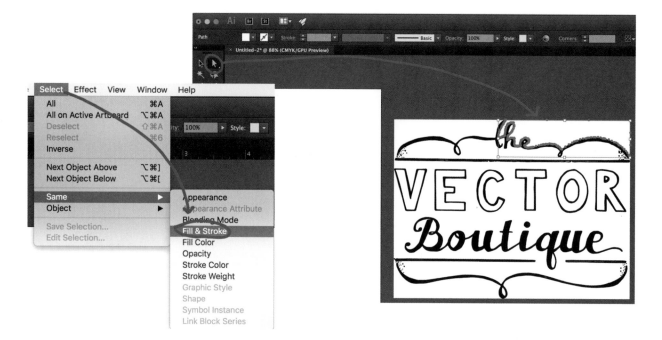

STEP FOUR

When you expand the tracing, Illustrator converts the white background of the image into vector shapes as well. To delete this, use the "Direct Selection Tool" to select one of the white shapes, and then choose "Select" > "Same Fill and Stroke." All of the white background shapes will be selected, and you can delete them in one step.

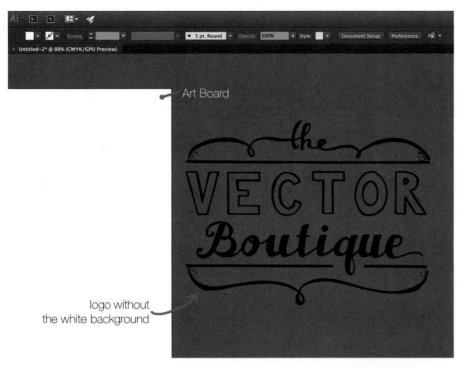

Art Board

logo without
the white background

Now, although Illustrator's art board is white, if you drag the logo off the art board you can see that it is free of the white background. Now if you want to change the logo's colors or adjust some spacing, for example, you can select the whole logo or small sections and make adjustments as you wish. The images below illustrate a few things I did to my logo.

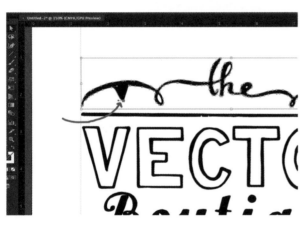

You can select individual anchor points and move them individually using the "Direct Selection Tool." I deleted the small shading dots from my original drawing.

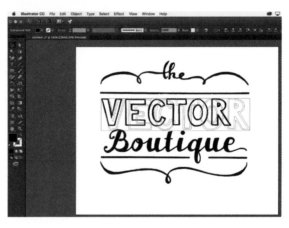

I moved some pieces of my logo around so that the spacing would flow better.

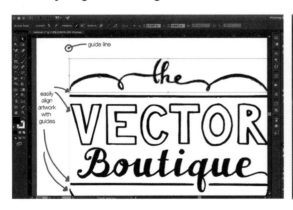

I also set up guidelines so that I could line up everything symmetrically.

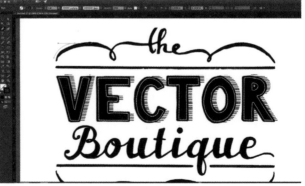

I added in additional details to my hand lettering and fixed individual anchor points with the "Pen Tool" and the "Smooth Tool."

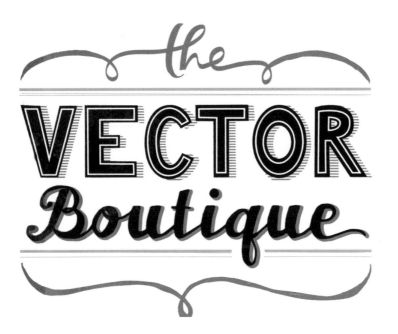

STEP SIX

Here is my original lettered logo in vector format. The imperfect lines give the logo a handmade quality that is perfect for the branding for a logo that is based around converting hand lettering to custom vector graphics.

STEP SEVEN

You can keep your vector logo black and white, or you can explore color and patterned swatches to add visual interest. It's a good idea to keep a black-and-white version and a color version of any logo. Save your work as an EPS vector file.

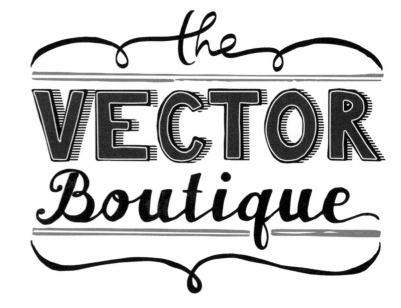

ARTIST'S TIP

YOU CAN ALSO SAVE A HIGH-RESOLUTION PNG FILE. THE PNG FILE TYPE IS NOT VECTOR-BASED, BUT IT ALLOWS YOU TOO KEEP THE TRANSPARENCY BEHIND YOUR LOGO. THIS IS A GREAT OPTION FOR CREATING A WATERMARK TO PUT OVER PHOTOGRAPHS.

Manually Drawing the Logo

Below are some tips for manually drawing the logo using the "Pen Tool" in Illustrator. This technique can give the image a more uniform and polished look. You can trace the entire sketch or just parts of the logo.

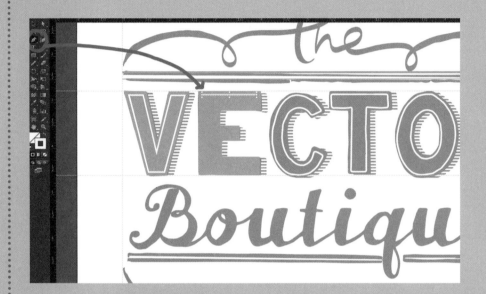

To manually trace the logo, first turn down the opacity of your logo to 50%, and lock it on its own layer. Create a new layer, and trace over your logo using the "Pen Tool" to place anchor points. I prefer to trace in a bright green color so I can easily distinguish my tracing from the original layer.

In this example, I used my original sketch as a guide but created the word "VECTOR" with the "Pen Tool" and guides so that it would have a crisper appearance that resembles digital sans serif fonts.

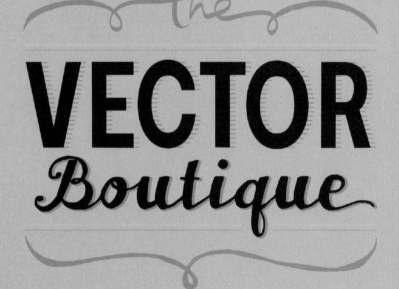

DIY HAND-LETTERED TYPEFACE

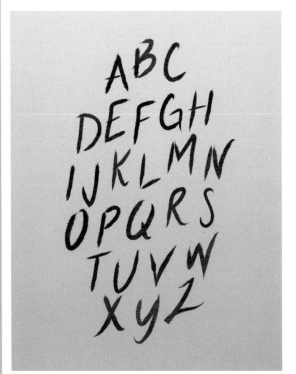

You love hand lettering—the authenticity, the unique character, and even the little imperfections. Have you ever wondered how to turn your unique lettering style into your very own hand-lettered typeface?

There are several ways to create fonts and a wide variety of font-editing programs to choose from. Professional typographers spend hours meticulously perfecting their typefaces and may use expensive font-editing software that allows them to precisely hone in on their trade, but don't let that deter you from trying your hand at creating your own font. I promise you don't have to be a professional typographer, and you don't have to spend a lot of money to make your very own beautiful, hand-lettered typeface!

In this tutorial I'll walk you through some basics of setting up hand-lettering alphabet glyphs, and then I'll demonstrate two possible ways to convert your lettering into a typeface.

MATERIALS

- Paper
- Archival micro pigment ink brush pen
- Adobe Illustrator
- Font editor of your choice*

*This tutorial demonstrates how to create a typeface two ways:
 –Option A: Simple, fast, and free. Create a font with MyScriptFont.com.
 –Option B: Font-editing software basics. Create a font with the font editor Glyphs Mini App, which requires Mac OS X 10.6.8 or newer.

HAND LETTER THE TYPEFACE

STEP ONE

Hand letter your alphabet characters on paper. I wanted my typeface to have a dry-brushed quality, so I used a brush pen on textured paper. If necessary, sketch the lettering on graph paper to keep the letters proportionate.

116

ABCDEFGHIJKLM

NOPQRSTUVWXYZ

&1234567890

STEP TWO

Redraw and perfect any letters you aren't completely satisfied with. Consider the cap height and baseline, as well as the ascender height, x-height, and descender height. Since my typeface is an all-caps brush script and I want it to feel hand-brushed, I purposefully varied the size of my letters, the baseline, and the cap-height slightly. Once you are happy with all your characters, photograph or scan your work.

CONVERT THE LETTERING TO VECTOR ART

STEP ONE

Place the artwork on a new Illustrator document and, with your work selected, use the "Image Trace" feature to convert the hand lettering. (See the vector tutorial on pages 110-115 for additional details.)

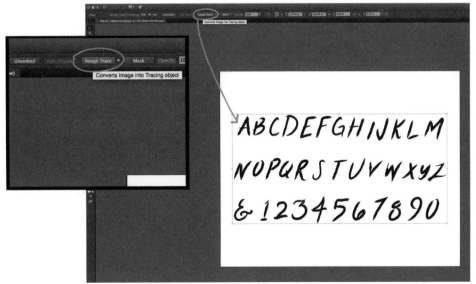

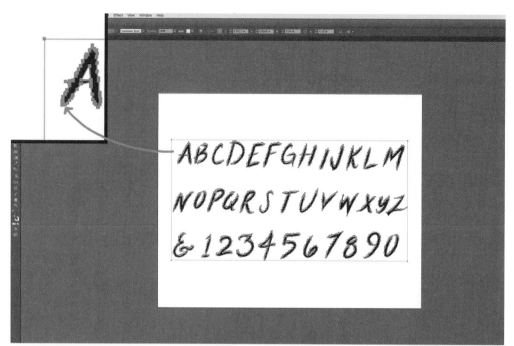

STEP TWO

Use the "Expand" button to convert the image-traced object into paths. Refer to pages 110-115 for a refresher on using the expand tool.

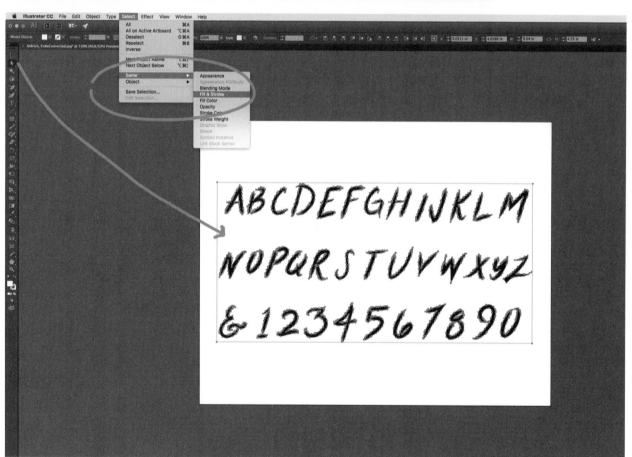

STEP THREE

Use the "Direct Selection Tool" to select an area of your lettering that is filled with white. With the white selected, go to "Select" > "Same" > "Fill & Stroke." Once all of the white areas are selected on your work, delete them so that only the lettering remains.

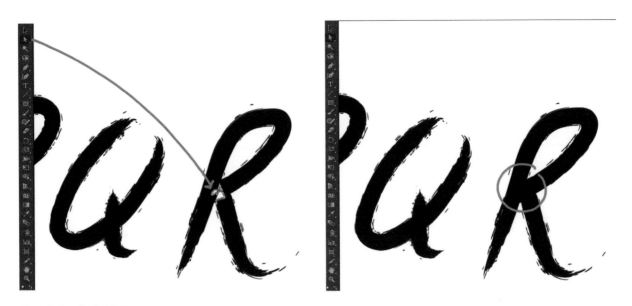

STEP FOUR

Look over each letter and symbol. Delete any imperfections, and smooth out any jagged lines.

ARTIST'S TIP

AS AN ALTERNATIVE, IF YOU'D LIKE TO SKIP HAND DRAWING THE LETTERS ON PAPER AND IMPORTING, YOU MAY USE THE "PEN TOOL" IN ILLUSTRATOR TO DRAW YOUR CHARACTERS DIRECTLY IN THE PROGRAM.

A B C D E F G H I
J K L M N O P Q R
S T U V W X Y Z &
1 2 3 4 5 6 7 8 9

STEP FIVE

Organize all of the letters, and scale them appropriately so that they are relatively uniform in size.

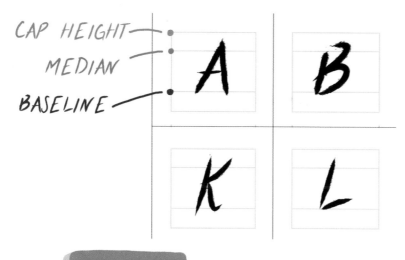

CAP HEIGHT
MEDIAN
BASELINE

STEP ONE

Research and select a free online font creator. Download the font template. Then copy and paste your vector lettering onto the template and arrange it accordingly. Make adjustments to size and spacing as needed to match the baseline, cap height, and median.

ARTIST'S TIP

TO INSTALL YOUR NEW FONT ON A MAC, CONTROL-CLICK ON THE FILE AND CHOOSE "OPEN WITH" > "FONT BOOK."

A	B	C	D	E	F	G	H	I	J
K	L	M	N	O	P	Q	R	S	T
U	V	W	X	Y	Z	A	B	C	D
E	F	G	H	I	J	K	L	M	N
O	P	Q	R	S	T	U	V	W	X
Y	Z	1	2	3	4	5	6	7	8
9	0	&	.	,	:	„	"	?	!

STEP TWO

Save and upload the template to the font creator website. Name your font, and select the TTF output. Press start to generate your font, and download the font file when it is complete. Now you can install your new font just like you would any other downloaded font. Your hand-lettered typeface is ready to use! This option doesn't offer any extra features for kerning or fine-tuning, but it is a simple, free way to start out.

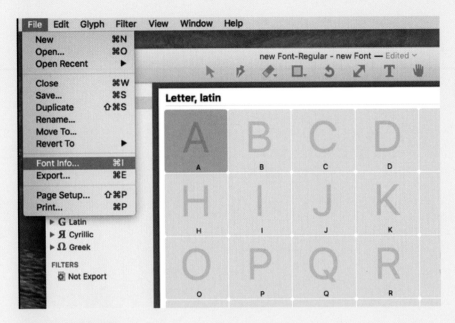

STEP ONE

Do a little research and decide which font-editing software is right for you. Depending on what software you use, these instructions may vary a little, but I will guide you through the basic steps. For this tutorial I'm using Glyphs Mini App. Open the software, and select "File" > "New." Then select "File" > "Font Info."

STEP TWO

Now you can name your font and fill out additional information accordingly. This screenshot shows a sample of how I set mine up.

STEP THREE

Resize all of your vector letters and symbols in Adobe Illustrator to be 1000 x 1000 px (pixels). In the font software options, choose which letters, numbers, and symbols you want your finished typeface to have.

STEP FOUR

Once you are ready, double-click on each individual glyph in the font software, and copy and paste in the corresponding letter from Illustrator. Size and arrange the letters accordingly.

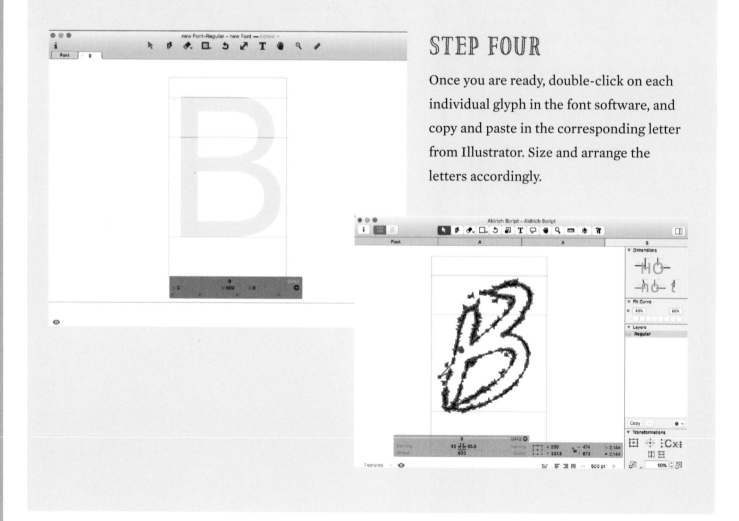

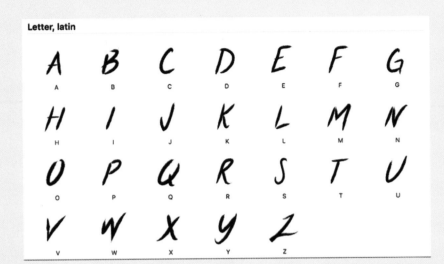

Letter, latin

Copy all of the letters and symbols to the appropriate glyphs.

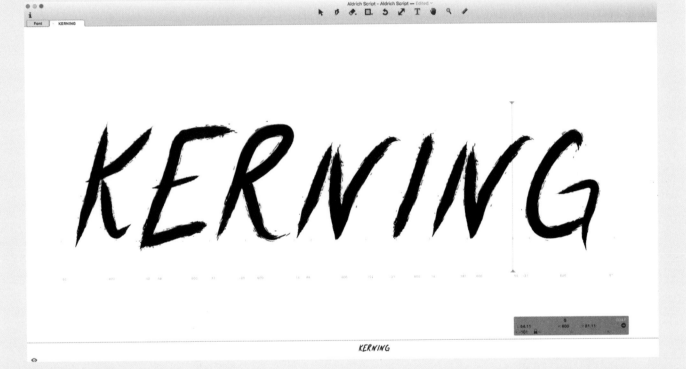

STEP SIX

You may find that you need to adjust the kerning for your letters. Kerning is the spacing between letters. To adjust kerning in Glyphs Mini App, start by double-clicking to select a specific letter. With the "Type Tool" selected, hold down CMD+OPTION+F. Type some words to see how the kerning looks. To adjust the kerning, select the space between letters, hold down CMD+OPTION, and use the Left/Right arrows on your keyboard to adjust.

STEP SEVEN

Generate the finished font by selecting "File"> "Export." I recommend exporting as an OTF, which stands for OpenType Font.

STEP EIGHT

Install your font! After installing the font, experiment with it and note any changes or adjustments you would like to make in your font-editing software.

A B C D E F G H I
J K L M N O P Q R
S T U V W X Y Z
1 2 3 4 5 6 7 8 9 0
. , : " " ? ! &

STEP NINE

Now you can use your very own font for hand-lettered typography fun! With these basics, you'll be able to perfect your skills and create as many fonts as you like. Happy typing!

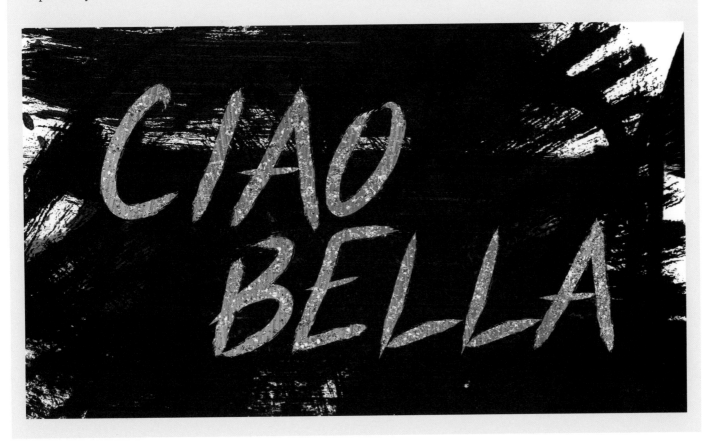

MODERN MURAL

MATERIALS

- Pencil & paper
- Ruler & scissors
- Double-sided tape
- Painter's tape
- Plastic drop cloth
- Craft knife
- Interior paint & acrylic paints
- Paintbrushes: large brushes & an edging brush for the wall, fine brushes for details
- Paint tray & rollers
- Small paint bucket
- White opaque felt pen
- Paint pens
- Hand wipes
- Ladder

If you're a fan of geometric design trends, you'll love this modern mural project, which uniquely combines geometrics with contemporary sans serif lettering. Take this concept and make it your own. The mural in this tutorial is for a little girl's room, but you can modify the colors and phrases to fit any space. For instance, try sophisticated monochromatic shades of black, white, and gray for an upscale, mod home office!

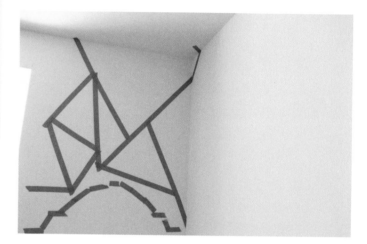

STEP ONE

Roughly sketch out the mural and conceptualize where it will go on the wall.

Prepare the space, and clear the area so you have plenty of room to work. Tape off where furniture goes, so you have a guide for how your mural will interact with the décor. Here you can see I taped off where a headboard will be. Begin taping off geometric shapes. Align corners and press down firmly. When applying long lines of tape, be sure not to stretch and pull the tape too hard. When the tape is stretched too tightly it won't lay flat or adhere correctly.

My mural includes endearing phrases from around the world:

- **i koråson hu** = "my heart"
 Origin: **Chamorro**
- **honey**
 Origin: **English**
- **keiki** = "child"
 Origin: **Hawaiian**
- **Liebling** = "darling"
 Origin: **German**

- **mija** = short for *mi hija*, "my daughter," often used as an endearment not just for daughters, but all girls
 Origin: **Spanish**
- **mon petit chou** = "my little cabbage," a phrase of endearment akin to calling someone "honey" or "darling"
 Origin: **French**

- **my dear**
 Origin: **English**
- **neni girl** = "baby girl"
 Origins: **Chamorro and English**
- **stella** = "star"
 Origins: **Italian and Latin**
- **yuriko** = a name meaning "lily child"
 Origin: **Japanese**

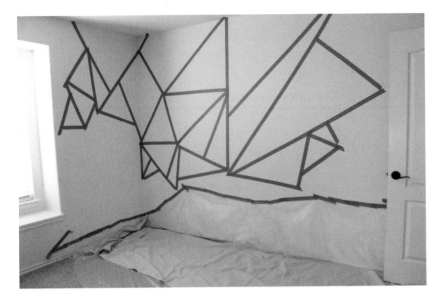

STEP TWO

Tape and align all the corners. Then lay a drop cloth over the floor and tape it up the wall to protect against paint splatter.

STEP THREE

Set up a workspace, and keep hand wipes and paper towels ready to easily clean your hands and brushes. Begin painting the sections. When painting over tape, apply brush-strokes pulling away from the tape. This precaution will help keep paint from seeping underneath.

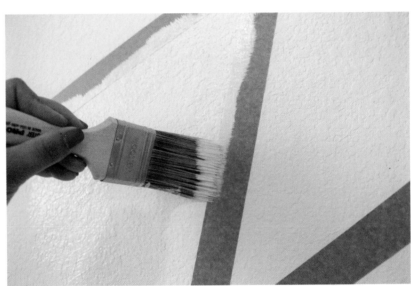

STEP FOUR

You can tape off the ceiling, or you can use an edging brush, which is my preference. To paint edges, load your brush by dipping just the ends of the bristles into the paint, and brush off the excess on each side. Position the brush about one inch from the edge you're trimming, and then push the bristles upward to meet the line. After trimming where the wall meets the ceiling, use a paint roller to cover large areas quickly.

STEP FIVE

Paint one color at a time until
you have finished all the shapes.
Remove the tape carefully as
soon as you are done painting.
It's best to remove painter's tape
when the paint is not completely
dry. Slowly pull away the tape at
a 130-degree angle to maintain a
crisp, clean line.

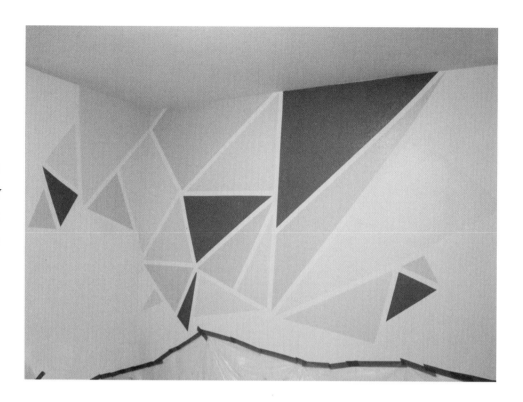

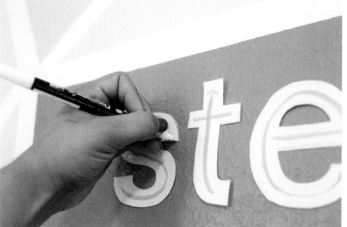

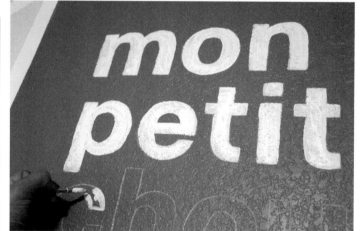

STEP SIX

While the paint is drying, prepare the lettering. There are many techniques for hand lettering murals.
You can work freehand or use stencils. I created my own stencil alphabet in a sans serif font that complements the
geometric shapes. Line up and space out the lettering, using a ruler to keep the spacing between letters even. Use
double-sided tape to stick the letters to the wall, and trace around them with a white opaque felt-tip pen. Then use a
fine-tipped paintbrush dipped in white acrylic paint to outline the lettering; fill in the outline with paint.

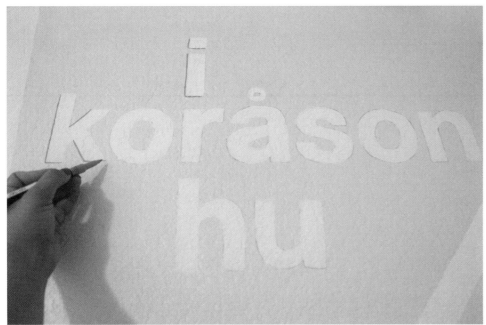

STEP SEVEN

Once the lettering is dry, you can go back and add in shadows and details with acrylic paint on a brush or a paint pen.

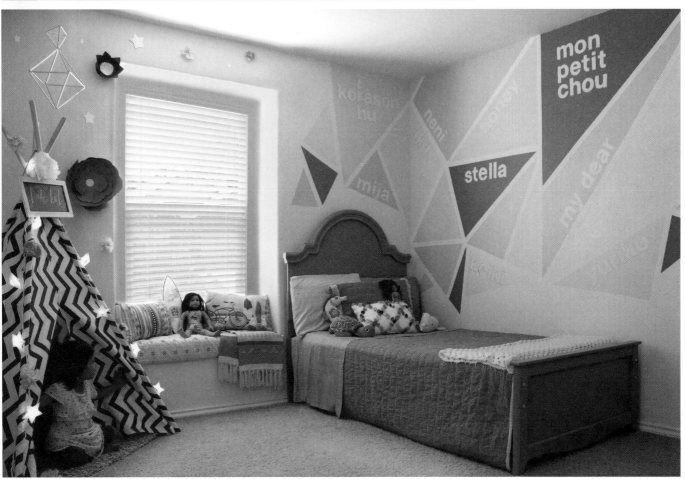

STEP EIGHT

Repeat the process for any space where you want to add a word. Let the paint dry, and you have a modern, worldly mural that is sure to be a conversation piece in the room. Move your furniture back in place and have fun staging your new mod space.

FABRIC PAINTING

MATERIALS

- Pencil
- Acrylic paint
- Paintbrushes
- Textile medium
- Plain fabric tote bag
- Cardboard
- Iron

Painting on fabric not only results in a cool screen-printed look, but it's also really fun! You can make t-shirts, aprons, tote bags, and so much more. To make your painted fabric last longer, you'll want to add textile medium to the paint. This will allow the paint to go through the washing machine!

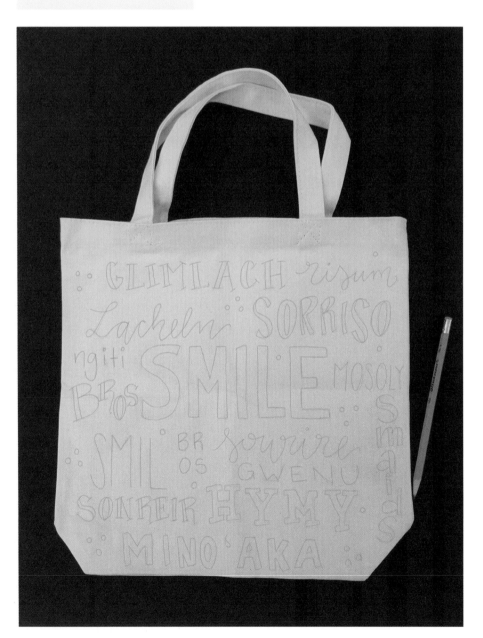

STEP ONE

Start by ironing your tote so that the surface is smooth. Then use a pencil to sketch the words or letters lightly onto the front of the tote. I lettered the word "smile" in many different languages.

Line the inside of the bag with a piece of cardboard to prevent paint from bleeding through.

STEP THREE

Prep your acrylic paint by adding textile medium and mixing it in.

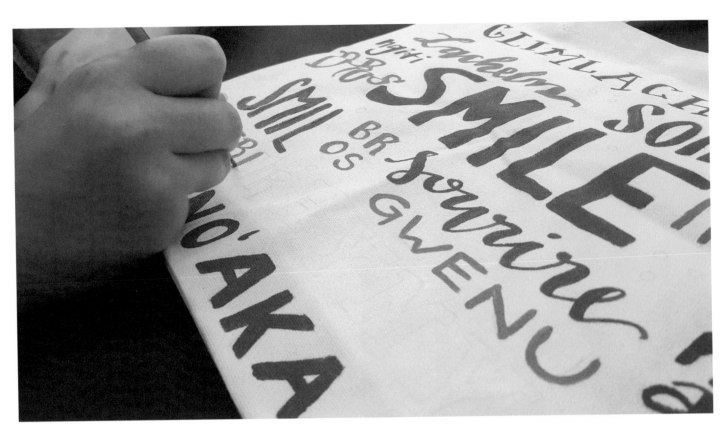

STEP FOUR

Start painting! I switched between two colors to give the words dimension. Note how the varied lettering styles highlight the different languages.

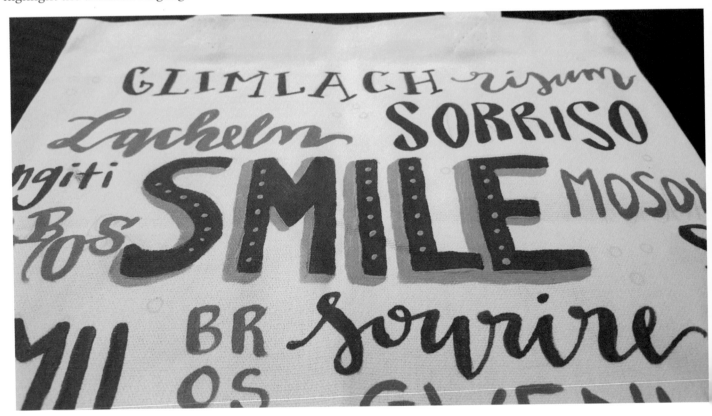

STEP FIVE

Use a third color of paint to add a 3-D effect to the central lettering, as well as some decorative touches.

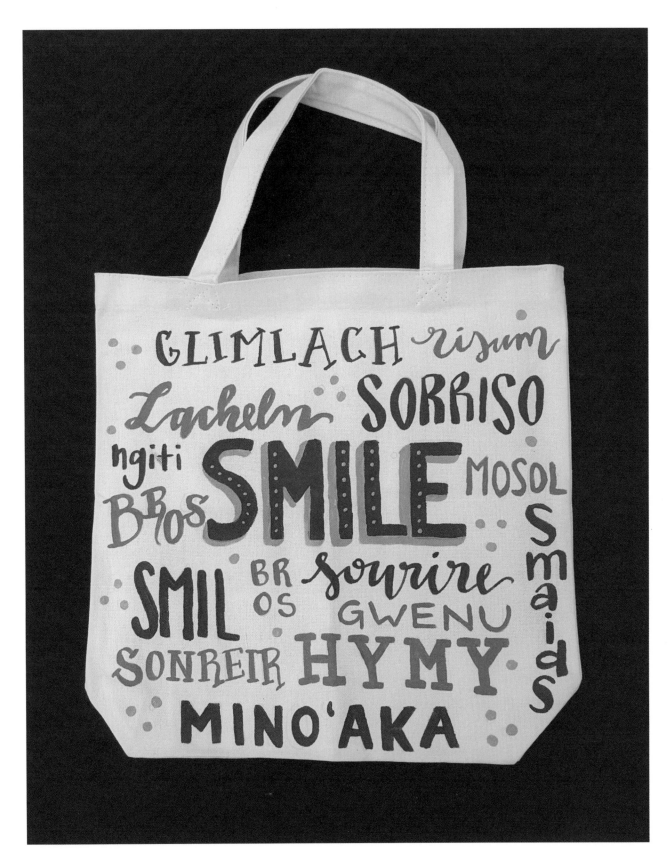

STEP SIX

Allow the paint to dry for 24 hours, and then follow the textile medium directions to seal the paint with a hot iron. Then have fun with your newest accessory!

DIY BLOCK PRINT

Modern block printing implements a carved design on wood or other material to print on paper and textiles. The carved block is covered in ink and used to transfer the image. Wood, linoleum, and rubber are a few of the most common materials used for this technique. In this tutorial you'll learn how to combine your love of hand lettering with block printing. We'll walk you through the process of carving your own linoleum block. From there, you'll find some simple tips for printing your image on paper and fabric. This versatile project can be easily adapted to create a custom monogram, business logo, or art print!

MATERIALS

- Pencil
- Regular printer paper or tracing paper
- 4″ x 5″ linoleum block
- Lino handle & line cutters #1, #2, and #5
- Block printing ink
- Brayer (ink roller)
- Tray or glass for inking
- Tape
- Scissors
- Acrylic paint mixed with fabric medium for printing on fabric (optional)

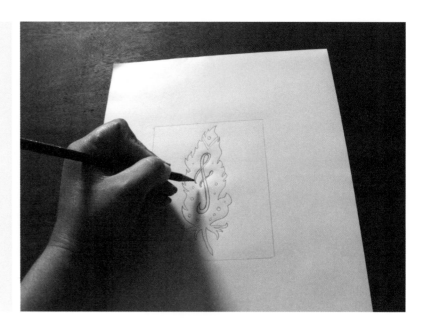

STEP ONE

Trace the linoleum block, and then sketch your concept on paper with pencil. I chose to do a decorative design with a feather and the letter "f" in the center.

ARTIST'S TIP

YOU MAY PURCHASE YOUR BLOCK PRINTING TOOLS SEPARATELY, OR YOU CAN PURCHASE A BLOCK PRINTING KIT AT YOUR LOCAL ART & CRAFT STORE.

Brief History of Block Printing

Wood block printing is one of the oldest forms of printmaking. The earliest examples of this type of printing process originate in China. The technique grew to be used widely throughout East Asia as a way to print on fabrics, paper, and books. As time went on, this technique evolved and adapted as it spread around the world. One genre of Japanese woodblock printing, *ukiyo-e*, produced beautiful, intricate art prints of landscapes, human forms, plants, and animals. In India, ornate patterns are carved and printed on beautifully colored textiles. Wood-cut printing techniques came to Europe with the arrival of paper and became a popular form of printing around the 1400s, eventually becoming one of the main methods for printing book illustrations with movable type into the 16th century.

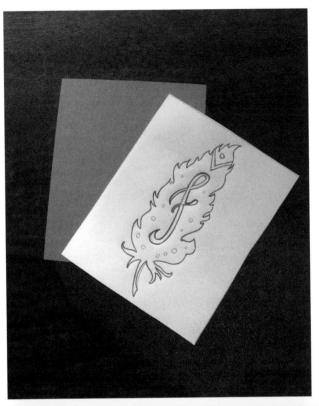

STEP TWO

Perfect your drawing so that you have a nice, smooth, dark pencil outline. Erase any stray lines. Then cut out the design.

ARTIST'S TIP

WHITE-ON-BLACK OR BLACK-ON-WHITE? THE CHOICE IS YOURS. CONSIDER HOW YOU WANT THE FINAL PRINT TO APPEAR. DO YOU WANT YOUR LETTERING TO BE IN THE NEGATIVE OR POSITIVE SPACE?

WHITE-ON-BLACK: LINES AND DETAILS ARE CARVED AWAY. THE FINAL DESIGN WILL HAVE WHITE DETAILS, AND THE NEGATIVE SPACE WILL BE PRINTED.

BLACK-ON-WHITE: THE NEGATIVE SPACE IS CARVED AWAY. LINES AND DETAILS WILL BE PRINTED, AND THE NEGATIVE SPACE WILL BE WHITE.

YOU COULD EVEN COMBINE THE TWO TECHNIQUES!

STEP THREE

Place your pencil sketch facedown on the linoleum surface, and tape it to the block. Use a hard-lead pencil to apply gentle, even pressure, scribbling over the entire image. Don't press too firmly—you don't want to indent the linoleum. Apply just enough pressure to transfer the drawing to the linoleum surface. You can lift up a corner of the sketch to check your progress and determine if you need to press more firmly or more gently.

STEP FOUR

Fill in any areas that didn't transfer. Now your image is reversed onto your block and ready to be carved. If you haven't carved on linoleum before, test your carving tools on an area of the block that you intend to carve away. Be sure to carve on a slip-free surface with bright lighting. Hold your tool firmly, but don't press too hard. Always carve away from you, and keep your other hand away from the direction in which you are carving.

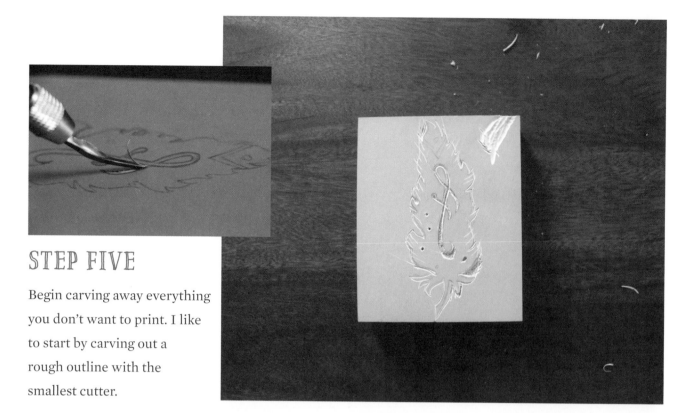

STEP FIVE

Begin carving away everything you don't want to print. I like to start by carving out a rough outline with the smallest cutter.

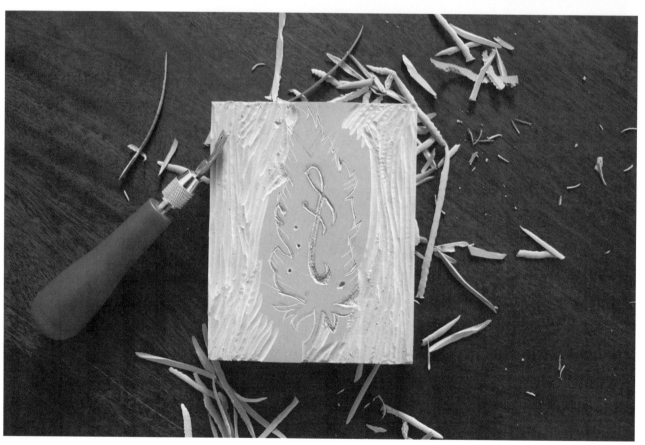

STEP SIX

Use the larger carving tool to carve out larger areas and the background.

STEP SEVEN

Finesse the intricate details carefully and patiently with the smallest carving tool. Carve away the finishing touches.

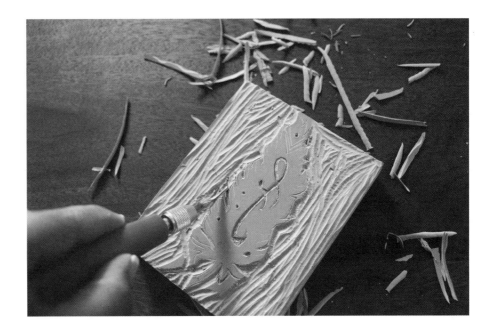

ARTIST'S TIP

IF YOU NOTICE INKED AREAS THAT YOU DON'T WANT TO PRINT, CAREFULLY DAB THEM WITH A PAPER TOWEL AND CARVE AWAY THOSE AREAS.

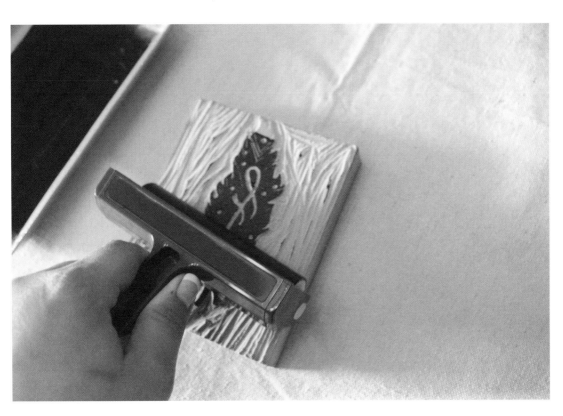

STEP EIGHT

Now you are ready to print! Apply a small amount of ink in your ink tray. Roll out the ink so that it covers the entire tray and you have a thin, even coat of ink on the brayer. Carefully roll the brayer up and down on the carved block with even pressure to transfer the ink.

STEP NINE

Test a few ways of transferring the image on practice paper to see what works best with your carving. First, place the block face-side up on a firm surface. Place the paper on the block, and roll a drinking glass carefully over the surface.

Second, try placing the paper on an even surface, and carefully lower the block evenly onto the paper. Press firmly and remove (shown here).

Third, try placing padding, such as a piece of cardboard on a hard surface. Place the paper on the padding, and then place the block on the paper and apply firm, even pressure.

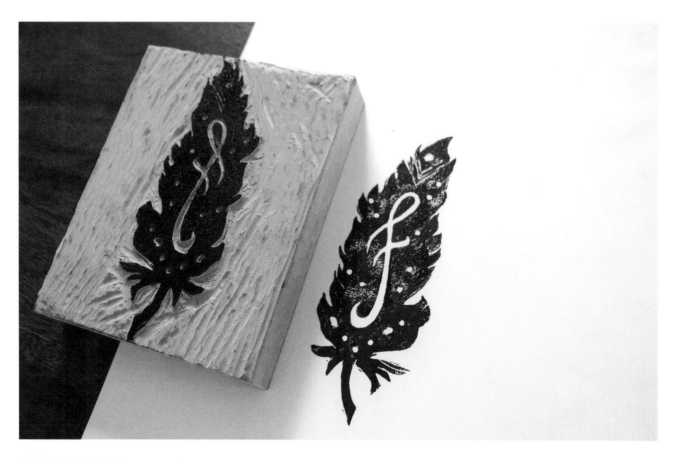

STEP TEN

Once you have determined which method works best with your block, you're ready to print on the paper or other surface of your choice!

Print on Fabric

Once you are satisfied with how the block is printing on paper, why not try your hand at printing on fabric? Practice with spare fabric, just like you did on scratch paper. Keep in mind that different fabric textures will absorb ink differently. For instance, a finely woven fabric will result in a smooth print similar to paper. Fabric with more texture, such as a dishtowel, will result in a more weathered appearance.

Stretch the fabric over a piece of cardboard on a solid, flat work surface. Mix acrylic paint with fabric medium, following the directions on the fabric medium. Roll out the homemade fabric ink on a tray, and transfer the ink to your block print with the brayer. Place the block print on the fabric, and press down firmly.

Working with different papers and fabrics will result in a range of unique prints, with no two exactly the same! After experimenting with these block-printing methods, you can dream up many more projects and printing applications. From paper and books to apparel and home goods...the possibilities are numerous!

INSPIRATION GALLERY & BONUS PROJECTS

Once you've mastered the basics of lettering, there's no end to the ways you can implement hand lettering and typography in creative ways. Think beyond paper or canvas—you can letter on just about anything, from wood and glass to ceramics and fabric. The sky truly is the limit! Take a peek at these inspired ideas for creating beautiful hand-lettered pieces. You'll find step-by-step tutorials for all of these projects, plus more, at www.quartoknows.com/page/lettering.

Painting this Latin phrase in colorful lettering across a custom clock dial is the perfect reminder to make the most of each day. With a little time and creativity, you can create a unique, functional clock that is charming and uplifting.

Impress your dinner party guests by hand lettering on ceramic pieces, such as bowls and plates. With the right pen and a few strokes and swirls you can add a touch of glam to any event.

If you enjoyed the illuminated lettering techniques on pages 44-57 try applying those same techniques with mixed media to create a mesmerizing, illuminated masterpiece, like this whimsical letter brought to life with a mermaid under the sea.

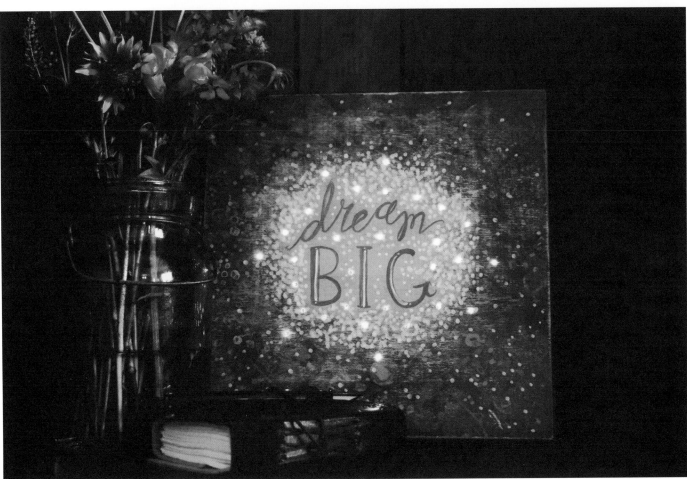

A pretty, lighted canvas is a creative way to add a subtle glow to any room—it can also be used as a decorative night-light! In this piece, the glowing lights dance around playful hand lettering on an abstract background inspired by Impressionism, the Milky Way, and Texas wild flowers at dusk.

141

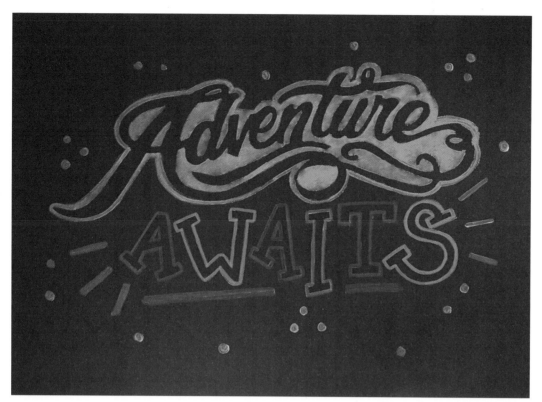

Mural painting is an amazing application for lettering. Try kicking it up a notch with blacklight paint for an unexpected twist!

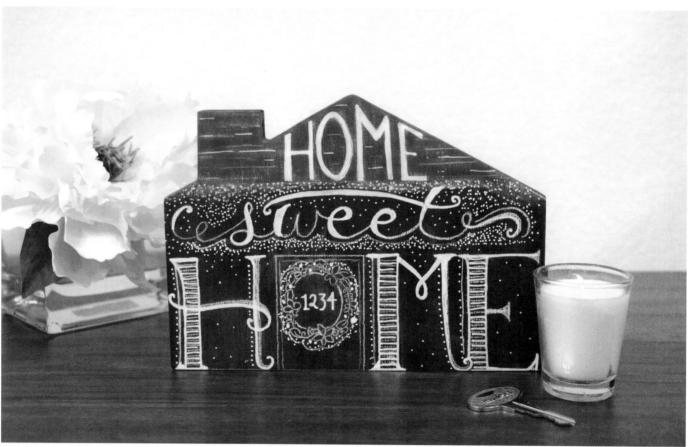

This handmade sign is an inexpensive yet thoughtful gift to make for a new neighbor or a friend who has moved into their first home. You can find wood cutout shapes at your local craft store or online. Painting the sign with chalkboard paint is simple and fun. With a little creativity and some chalk lettering, it's easy to make this unique, custom gift.

This DIY wooden growth chart is a wonderful way to mix your personal hand-lettering style with your heritage and family traditions. This special keepsake can travel from home to home through the years and be passed down to future generations. It would also make a very thoughtful gift for a loved one or friend who is starting a family of their own.

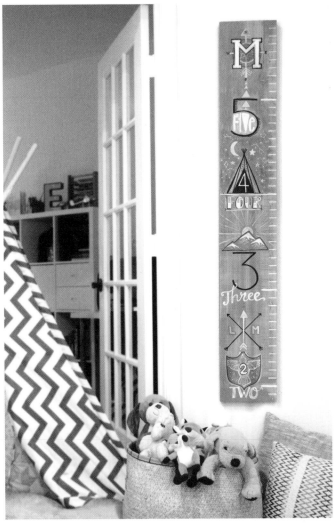

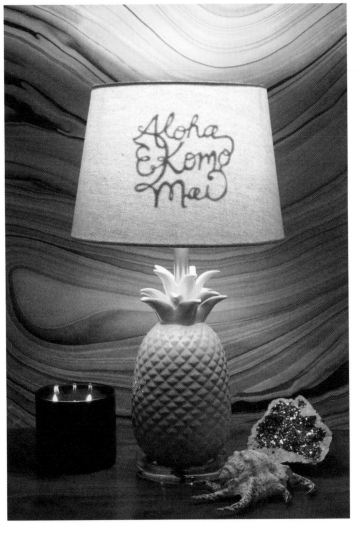

A custom lettered lampshade will fill any room with a warm glow that will make guests feel welcome and at home. Use a short phrase or quote that is special to you—or simply monogram it with your initials. This is a great addition to an entryway, guest room, nursery, or any other space in your home.

ABOUT THE AUTHORS

Gabri Joy Kirkendall is an artist and illustrator from the beautiful Pacific Northwest. She specializes in hand lettering and runs an online business designing a range of products for companies such as Threadless and Society6. She has had the pleasure of working with clients as far flung as Spain, Australia, and New Zealand. Gabri has a BA in political science and French literature, but she returned to her roots in art after being diagnosed with cancer in 2009 and is now happy, cancer-free, and into all things creative. In her spare time she is a coconut-chai-drinking, vintage-buying, book-obsessed, Dr. Who-nerd who lives with her husband, John, and their Labradoodle puppy, Tova, in Puyallup, Washington.

Jaclyn Anne Escalera is a Tacoma-born native with an island-girl spirit. She is a visual communicator who earned her BFA with an emphasis in graphic design and has professional experience in corporate design, non-profit, and small-business branding. Jaclyn is passionate about creating mood-evoking hand lettering, colorful designs, and fanciful illustrations. She has lived and worked as a designer in London, Oahu, and the Pacific Northwest. Today she runs JAE Creative from her home office in Austin, Texas. You can usually find her designing with her trusty dog at her feet and ukulele music playing in the background. Jaclyn is also a proud mom and Army wife, who receives her inspiration from nature, travel, and her daughter's fresh, innocent perspective of the world around her. When she isn't working on client projects she enjoys painting, crafting, home DIY projects, and days spent outdoors hiking or on the water SUP-boarding with her family.

ACKNOWLEDGMENTS

Gabri would like to thank her parents and siblings for all their love and support, her husband, John, for his help and photography skills (and for tolerating the house getting blown up with craft projects), her sister Kerri for her photography and tattoo printing prowess, Karen for the loan of vital office supplies, Erin—who is partially responsible for this book happening at all—and all and sundry who supported her, even on days when she had paint all over her hands and glue in her hair. Gabri would like to dedicate this work to her mother-in-law, Kim, who believed in her before she believed in herself. Belief truly is the greatest gift you can give.

Jaclyn would like to thank her husband, John, for his faith in her and love even from a world away (*hu guaiya hao*), her parents and in-laws for their ceaseless support and for flying to Texas to watch their grandbaby while she worked, all her dear friends near and far, her Creekside neighbors who have been a village of support, Professor Avila for taking the time to mentor and make a difference in student lives, Bea-Marie for her words of wisdom, Janelle for her photo artistry, and Erin and Gabri for bringing a dream into existence. Jaclyn would like to dedicate this work to her daughter Jasmine Anne, her greatest source of inspiration and favorite work of art.